ART & DEATH

ART & DEATH

*A Collection of
Prose & Poetry*

Series Editor
Marcus Reichert

ZIGGURAT BOOKS
International

Front cover painting (detail): Stephen Newton, *Chair, Door,
Window*, oil on canvas, 72 x 80 ins, 1999
Back cover photograph (detail): Marcus Reichert, *Morse Drive,
Burlington, April 1982*

UK office: 27 St. Quentin House, Fitzhugh Grove,
London SW18 3SE, England
Editorial office: 6 rue Argenterie,
30170 St. Hippolyte du Fort, France
Enquiries: zigguratbooks@orange.fr

Distributed by Central Books Ltd.
99 Wallis Road, London E9 5LN, England
Tel UK: 0845 458 9911
Fax UK: 0845 459 9912
Tel International: +44 20 8525 8800
Fax International: +44 20 8525 8879
email: orders@centralbooks.com

First Edition

ISBN 978-0-9561038-3-3

CONTRIBUTORS

Stephen Barber has been hailed by *The Independent on Sunday* as 'a cultural historian of real distinction ... (who) gives us superb, rich unjudgemental portraits of multi-stranded societies ... ' He is Professor of Digital Arts at the European Research Centre, Kingston University, and the author of *The Vanishing Map* (Berg Publishing Ltd., 2006), *Projected Cities* (Reaktion, 2002), *Extreme Europe* (Reaktion, 2001), *Edmund White: The Burning World* (Picador, 1999), *Fragments of the European City* (Reaktion, 1995) and *Antonin Artaud: Blows and Bombs* (Faber and Faber, 1993). Although he travels widely, he is based in London.

Henry Ralph Carse, poet and practical theologian, has lived in the Middle East for thirty-nine years. A graduate of Hebrew University (Jerusalem), The General Theological Seminary (New York), and the University of Kent at Canterbury, his Ph.D. thesis in theology is a postmodern study of pilgrim narratives. He is the Founder of "Kids4Peace" in Jerusalem, and the Executive Director of "Kids4Peace USA", bringing together Israeli and Palestinian youngsters of three faiths for encounter, fun and dialogue across the lines of conflict.

Judith Chandler is a painter. She is also a lecturer on art and post-graduate student at the University of Plymouth.

Antony Copley is Honorary Reader and Senior Research Fellow in the School of History, University of Kent. He has worked mainly in the fields of European and Indian history. He has published books on sexual morality in France, evangelical missionaries in India, and the Indian politicians, Gandhi and Rajagopalachari. His most recent publication, *A Spiritual Bloomsbury:Hinduism and Homosexuality in the Lives and Writings of Edward Carpenter, E.M Forster and Christopher Isherwood* (Lexington, 2006), is presently being republished in India by Yoda Press under the revised title of *Gay Writers in Search of the Divine*. He is currently putting together a book on Art, Music and Spirituality in the 20th century.

Piers Faccini studied painting at the Beaux Arts in Paris between 1988 and 1990. He has been represented by Galleria Spicchi dell'Est, Rome and by Lucy B. Campbell Fine Art, London. In 1996, Faccini formed the band Charley Marlowe before embarking on a solo career in 2002 recording the critically acclaimed albums *Leave No Trace* in 2003, *Tearing Sky* in 2006, and *Two Grains of Sand* in 2009. He has also recorded soundtracks for the BBC, Channel 4, and the South Bank Show. He lives and works in the Cévennes in France.

Michael Florescu is a writer and an art critic. He was born in London and studied at Westminster School before attending Trinity College, Dublin where he developed a lifelong interest in the theatre. Florescu emigrated to New York in 1976 at the request of the late Betty Parsons and became the director of her gallery. While in New York, he wrote numerous exhibition reviews and catalogue introductions. He has also worked as a cook and run his own restaurant. He now lives and writes in Siracusa, Sicily.

Dom Gabrielli studied literature at Edinburgh University and prepared for his doctorate in Paris and New York. In Paris, Gabrielli's passion for French literature and thought led him to begin writing, translating, and teaching. His published work includes translations of Battaille and Leiris. In the early 1990's, he left the academic world to travel and devote himself to writing, whilst pursuing various business ventures. Gabrielli currently lives in Paris and the Salento region of Southern Italy.

Donald Kuspit is an art critic, poet, and Distinguished Professor of art history and philosophy at the State University of New York at Stony Brook and professor of art history at the School of Visual Arts. He was formerly the A. D. White Professor-at-Large at Cornell University (1991-1997). He received the Frank Jewett Mather Award for Distinction in Art Criticism in 1983 (given by the College Art Association). His essay "Reconsidering the Spiritual in Art" appears in Blackbird: an online journal of literature and the arts.

Simon Lane is the author of four novels, *Le Veilleur, Still-life With Books, Fear,* and *Word of Mouth.* Currently in preparation is *The Real Illusion,* an anthology of his shorter writing with prints by the Brazilian artist Tunga. He has written for a wide variety of publications in Europe and the United States, and has worked in film, radio, and television both as a writer and an actor. Born in England, he has lived in London, Berlin, Milan, New York, and Paris. He now lives and works in Rio de Janeiro.

Stephen Newton is a painter whose work has been exhibited internationally. His academic career began with a B.A. from Leeds University and an M.A. from Nottingham Trent University. He went on to receive an M.A. (Distinction) in Art and Psychotherapy and a Ph.D. in Psychoanalysis and the Creative Process from the University of Sheffield. He is the author of *The Politics and Psychoanalysis of Primitivism* (Ziggurat Books, 1996) and *Painting, Psychoanalysis, and Spirituality* (Cambridge University Press, 2001). Stephen Newton is Visiting Professor at the University of Northumbria at Newcastle, England.

Roy Oxlade is a painter. His first one-man exhibition was held at the Vancouver Art Gallery in British Columbia in 1963 and since then he has had solo shows in London at Odette Gilbert Gallery, Reed's Wharf Gallery, and Art Space Gallery and at the Gardner Centre Gallery, University of Sussex. Group exhibitions have included the John Moores, The Hayward Annual and EAST International. His monograph *David Bomberg* was published by the Royal College of Art in 1973. He lives and works in Kent, England.

George Pattison is Lady Margaret Professor of Divinity, University of Oxford. Prior to this, he was an Associate Professor at the University of Århus (2002-03) and Dean of King's College, Cambridge (1991-2001). Pattison's written works examine the relaitonship between theology, culture and philosophy, and he has written on Martin Heidegger and Søren Kierkegaard. His latest book *Crucifixions and Resurrections*

of the Image, on theology and the arts, is published by SCM Press, Canterbury.

Amos Poe is an artist and filmmaker living in New York City. His film work includes *The Blank Generation*, *Unmade Beds*, *The Foreigner*, *Subway Riders*, *Alphabet City*, *Triple Bogey On A Par 5 Hole*, *Frogs For Snakes* and *Empire II*. He has written numerous screenplays and serves on the faculty of New York University, Tisch School of the Arts, teaching screenwriting and production.

Marcus Reichert is a painter and a poet who has also worked in film. His filmworks are held in the Archive of the Museum of Modern Art, New York. *Reichert: The Human Edifice* by Mel Gooding, with 100 photographs by the artist in colour, is published by Artmedia Press, London. *Displaced Person: Poetry, Pornography & Politics* (Selected Writings 1970-2005) and *Art & Ego: Marcus Reichert in Conversation with Edward Rozzo* are published by Ziggurat Books, London. He lives and works in the south of France.

Edward Rozzo is a photographer and teacher. His professional photography for major multi-national industries has taken him throughout Europe. He has taught in Italy, Switzerland, and Belgium and is now professor of Visual Culture Studies at the Bocconi University in Milan, Italy. He also teaches Retail Semiotics at the Ecole Superieure d'Arts Appliqués in Vevey, Switzerland. His design studio and home are in Milan.

Sr Anselma Scollard OSB is a member of an enclosed Benedictine order. Before entering St. Cecilia's Abbey, Ryde, IOW, she studied aesthetics as a post-graduate. She is also a sculptor.

Mike Von Joel, "...maverick editor of numerous widely circulated art periodicals" (Boston University), was born in Yorkshire and educated at leading art schools in the south of England. A long career as a writer in the art world includes the editor's desk at the seminal newspaper *Art Line* (1982-1996)

and more recently founding editor of *State* (a free newspaper platform for new ideas in art and culture) and inaugural editor of international art/photography hi-end magazine: *Photoicon*. He lives and works between London, the Kent coast, and southern Spain.

Contents

The Survival of Sensibility
Foreword by Marcus Reichert 1

ONE

Some Thoughts on Imagery and Death
Edward Rozzo 9

When Two Deaths Become One
George Pattison 17

The Endless Search, The Enduring Present
Sr Anselma Scollard OSB 25

And Death I Think Is No Parenthesis
Roy Oxlade 35

Snapshots: Velasquez's Philip IV,
Butchers' Shops and Bacon's Pity
Piers Faccini 43

Varieties of Death: A 20th Century Perspective
Antony Copley 49

Spiritual Transformation
Donald Kuspit & Stephen Newton 61

Chiasmic Painting: Art & Death
Judith Chandler 73

Horizontal and Vertical Images of Death:
Andrea Mantegna and
Michelangelo di Lodovico Buonarroti Simoni
Sr Anselma Scollard OSB 81

Armageddon: An Eternity
Mike von Joel 91

Disembodiment and Fracture
Marcus Reichert 99

TWO

Art and the Writing of Antonin Artaud's Death
Stephen Barber 103

Last Comment
Dom Gabrielli 111

Existence: Excerpts from a Notebook
Marcus Reichert 115

A Bowl of Cherries
Simon Lane 127

Last Time I Saw Cookie Blues
Amos Poe 139

A Child of Deir Istya
Henry Ralph Carse 145

So Long Gypsy: On the Murder of Claude Weiss
Dom Gabrielli 147

Art and the Death of Conscience
Stephen Newton 151

Searching for No One
Piers Faccini 169

Thirst and the Sea:
Death and the Poetry of Edmond Jabès
Dom Gabrielli 175

Letting Me Go
Michael Florescu 187

On Dying
Marcus Reichert 203

Reproduction Credits 204

Ronnie Kray, Letter to Marcus Reichert, 1980

THE SURVIVAL OF SENSIBILITY
Marcus Reichert

Ronnie and his twin brother Reggie Kray were not only notori-
ous East End gangsters who were alleged to have tortured their
enemies and murdered at least two of them, but also stylish
nightclub owners who mixed with Diana Dors, Judy Garland,
Frank Sinatra, and Lord Boothby among others. Ronnie and
Reggie were celebrities in their own right, and The Colonel, as
Ronnie was still known at Broadmoor, the high-security psy-
chiatric hospital at Crowthorne, always wore a sharp suit and tie
and large gold cufflinks when I visited with him. Other patients
included Ian Brady and Peter Sutcliffe and we all had our tea
and pork pies in the same room, the old auditorium, on visiting
day.

Ronnie liked me for a number of reasons, one of them being
that we were both artists (I was also a writer and director in film
at that time and struggling with the possibility of making a
feature on "the twins"). A paranoid schizophrenic, Ronnie was
the kind of artist who painted pictures that were beyond criti-
cism. His pictures could only be truly appreciated for what they
were: manifestations of his inner turmoil, of his soul. We traded
paintings; the one he gave me is entitled *The Long Road Home*.
His painting is about the yearning for solace in a world that is
nothing so much as a waking nightmare. If Ronnie were still
alive, I would have asked him to write something for this book.
I'm certain it would have been illuminating. His painting was
not an aspect of his therapy, although I imagine it had a calming
effect because it enabled him to momentarily empty himself of
his despair.

None of the writers represented here live in quite the bleak
circumstances in which Ronnie created his pictures, however an
atmosphere of resignation would seem essential to the circum-
stances in which we as writers and artists carry on trying to
make sense of things over the years. Our wondering takes many
forms, and our lives perpetuate that wondering in their often
inscrutable complexity and, occasionally, absurdity. If this book

is about anything – other than simply death in art – it is about the complexity of our relationship to death in its absurdity, although one might prefer the word *inevitability*. But then there are the violent instances when death has been the result of malevolence or hatred and they are here as well.

The writing is divided into two sections, although not necessarily two distinct sections. When we write about death as manifest in its particularity or its abstraction in art, we cannot help but write from both a philosophical and spiritual position. Section One addresses more specifically the way in which works of art that in some way confront the subject of death have affected or transformed our thinking. The numbing impact that the exploitation of death as a subject can have upon the sensibility of the viewer or reader is an especially timely subject. We therefore examine the subtly destructive results of an art that is practiced to succeed on a *sensationalist* level. Section Two finds its impetus in personal experience and grievance. It confronts the profound problem of the absence of self; that is, the problem of a *living death*. Despair finds a voice often loaded with anger, and pain, and with the need to sustain sentiment no matter how frail or wounded.

But the survival of our sensibility is perhaps the true subject of this book. When we write, our ideas take on a physical form that is naturally – or *unnaturally* – subservient to the dictates of the universe. But by writing we are denying the ephemeral aspect of our ideas, for now they exist in physical form! We write to deny death its final purchase, death's supposed claim upon our existence. Paradoxically we simultaneously accept the transference of our spiritual property into the hands of the great unknown (call it the Kingdom of God or call it Nothingness). Determined to be confident in the viability of our words, we write to compromise certain unacceptable realities. As we confront death in our art, we seek to contradict its imposition, that debilitating atmosphere of futility that lurks all around us.

When I wrote to Simon Lane in Rio to ask if he might contribute to *Art & Death*, he replied:

"Talk about art and death! These have been the twin or, rather, opposing themes of 2008, the inspiration of all the joys life and love and art and music and writing can offer, in stark contrast to the transparent interrogation that marks the infinite within which I so nearly lost myself not once, nor twice but perhaps three times since seeing in the New Year on our terrace, when the bandits of Rocinha gave us fireworks and red tracers to accompany wide smiles, hopeful kisses, a cracked Champagne glass to be hosed away so that the moonlight had some pools of water to play with."

I knew Simon had been unwell intermittently over the past year but to see his encounters with death rendered so succinctly startled me. And, unexpectedly, I received an e-mail from an old friend I'd had in mind to write something. Michael Florescu, who has lived in America for many years, said he had that Thanksgiving "struggled with the Angel of Death." He now lives in Siracusa on the island of Sicily. Later, Michael elaborated on his new life in Italy:

"First thing in the morning, I enjoy the three minute walk down to Piazza Santa Lucia to get a couple of croissants filled with ricotta, bringing them home to smear with a spoonful or two of the mermelatte I make myself, and eat them with caffe latte made in my own little espresso machine, then finish up with a glass or two of freshly squeezed sanguinella; or perhaps I'll stop off at the Calcio Bar Tabbacchi and have coffee and a nutella-filled pastry, depending on my mood. And a couple of days a week, at around 11:30, I'll be working at my desk and I'll hear the unmistakable cadences of the gimpy ricotta man announcing his arrival in his old Fiat convertible, and I'll call to him from my balcony to wait while I fetch a bowl and then tread carefully downstairs and get some fresh ricotta from him. So now you know why I did not choose Florida. It's where people my age go to die."

Then there were the writers I approached who were either in midst of taking care of someone who was about to die or who

had recently endured the loss of a loved one. George Pattison revealed that his mother had died and that this would be very much a part of what he would write. Judith Chandler replied to my request:

"Thank you for your invitation. I will most certainly give this some thought. As my mother and my brother's wife have both recently passed away, art & death seems quite fitting."

And Henry Ralph Carse wrote:

"My father started taking the morphine last night. During the day he went on a journey to the lake and watched the ospreys nesting. This caused the bleeding to resume. Also made him smile and tell stories. If there were more words for this would not someone have found them already?"

Sister Anselma Scollard, sequestered within St. Cecilia's Abbey on the Isle of Wight, had also been touched by death:

"One of our sisters died yesterday after four months of 'intensive preparation,' yet peacefully, quietly, simply returning to God. I say 'intensive' because it was so quick, but also so 'essential.' Everything was pared away and only the good and the best remained. It happened; it is not something for which one could have worked or planned in advance, although everything that preceded this death, conscious and unconscious was a preparation for it. In this sense it is like Art, which in its final outcome cannot be planned in advance. The idea in the mind remains an idea; what happens as a result of it is something individual and unique."

Self-indulgence, I think, is essential to "confessional" writing, whether rendered in academic or anecdotal terms. No restrictions were to be placed on the length or brevity of what anyone was to write. Dom Gabrielli typically went to the core of the proposition:

"I think that particular poem (*Thirst and the Sea* by Edmond Jabès) highlights the poet's intuition in…the extreme case of the death of a loved one. What I love is its positive and beautiful approach in the face of absurdity. Flows of desire, flows of the tragic. Maybe (one) could follow up on the question: is there a language for death, for dying?"

When I was twelve years old I wrote a poem which contained these two lines:

> *Younger among valleys of lead,*
> *the remaining become the dead.*

These lines often sang in my head as I read the writing that gradually came in and lodged itself in this book. Unpredictably, each piece bore the face of a stranger with a tale to tell. Although the voice was often familiar, the world of experience, speculation, and understanding that voice revealed often was not. Amos Poe put the case for death in art persuasively when he wrote of Nan Goldin's photographs of Cookie Mueller's* illness and death:

"Yes, I think Nan a great chronicler of that life, her work a sobering visual presence, place-markers for waste and useful courage and the sometime great notion that even on the edge of despair there can be beauty in human kindness."

*Cookie Mueller: writer, critic, and actress, 1949-1989

<u>ONE</u>

8

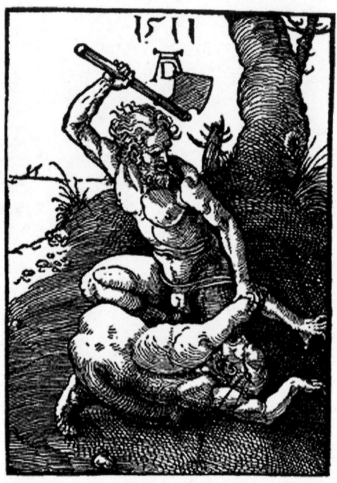

Albrecht Dürer, *Cain Slaying Abel*, 1511

SOME THOUGHTS ON IMAGERY AND DEATH
Edward Rozzo

The relationship between art and death is overwhelmingly complex because the relationship has been a constant since the beginning of man. Damien Hirst recently said that all art is about death, adding that collecting art is most certainly about the fear of dying. Death has always been a mystery and art has been the way to communicate that mystery, hopefully, in this way, going beyond death itself. So when we explore the mystery of death we inevitably find much expressive art dealing with the unknown, with life, with religion, with violence and even with sex. Death is related to life but the relationship is a metaphysical one, a spiritual one, a religious one and, sometimes today, a morbid one.

Art has been at the basis of spiritual communications since the beginning of time. Otherwise how could any simple object acquire any kind of spiritual power without being artistically decorated? Without decoration, it would be a mere object, devoid of any power. How could people understand what the spiritual leader of any tribe understood without artistic expression? You can't simply explain life and death in a matter of fact way without leaving out the emotional significance of both. So primitive man turned to expressing himself abstractly. There is no word for the feelings that accompany death, there are no ways to communicate that which you can not see. Here lies the birth of the abstract and its profound value in art.

Long before Freud's discovery of the role of the unconscious, man needed to express what was not seen, the metaphysical, the spiritual, the philosophical. These thoughts and feelings lived in an unseen world and the use of abstract symbols was the language chosen for their expression. Long before Plato's ideals, man needed a visualization for the metaphysical and he found it in repetitive symbols, in aligning stones, in placing things in some kind of human order, making them appear special. This simple alignment gave pleasure to the eye and provoked a strange sensation. Something had happened, something had

become special, magical. Ellen Dissanayake's research into homo aestheticus has furnished us with precious evidence of the intrinsic relationship between the spiritual and the artistic, and therefore between art and death. Her anthropological approach is in distinct contrast with the linguistic tradition which deconstructs the meaning of languages in order to emphasize their relativity. The consciousness of life and the fear of death, I believe, must be thoughts which exist before language. Therefore, Dissanayake's work brings art and artistic expression into the physiological construct of man and not just as part of his way to symbolically communicate. The Greeks understanding of beauty confirms, in my opinion, Dissanayake's hypothesis. The word aesthetic comes from the Greek word for sensation, meaning that what we consider aesthetic or harmonious or beautiful is so because it gives us a special sensation. A visual and emotional sensation. It's like the pleasure of hearing harmony in music, it is simply pleasing to the ear. It caresses our eardrums and gives us physical pleasure. We may intellectually appreciate other sounds and music, but musical harmony is indisputably pleasant to listen to.

Therefore, art in itself is intrinsically related to man and his primordial feelings about life and death. Evidence of prehistoric artistic expression relating to life and death can be seen in the use of abstract repetitive forms in cave drawings from the Paleolithic and Megalithic periods, on ceramics found in Mesopotamia 4000 B.C. in mosaics from Ancient Greece, thousands of years later in Japanese rake paths from traditional rock gardens, in the ancient Chinese symbol of Yin and Yang or on the floor of Saint Mark's Cathedral in Venice: life-death, male-female, good-bad, symbols of dichotomy, pleasure-pain, cyclic energy. We find the very same signs reappearing in Rhoda Kellogg's tests (see next page) on primary forms of infantile graphic expression done during the 60's. The graphic signs are the very same ones used throughout human history to represent cosmic and spiritual reality. All point to the intrinsic relationship between art and the abstract: life, death, and the spirit. At this point one does not have to stretch the imagination to see the

anthropological relationship between the concepts of life and death and their artistic expression.

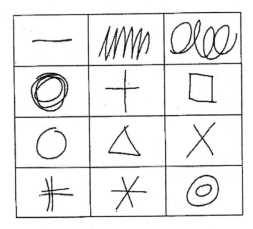

PRIME FORME DI ESPRESSIONE GRAFICA INFANTILE, CLASSIFICATE NEL 1965 DA RHODA KELLOG, PRESSO LA SCUOLA DI PEDIATRIA GOLDEN GATE, SAN FRANCISCO (CAL.), SULLA BASE DI CIRCA TRECENTOMILA DISEGNI ESEGUITI DAI BAMBINI DI VARI GRUPPI ETNICI.

Of course, religions have always used art to communicate the unknown, including death and its consequences. Whether promising eternal bliss, such as in Correggio's splendid cupola in Parma's Cathedral or condemning man to hell, such as in Dore's illustrations for Dante's Inferno, religion and religious thought have used artistic expression to impress the public and forge their thoughts in conformity to the overruling ideology of the day. Some of this has changed in contemporary society, leaving us with an individually deformed relationship between life and death: death as a separate entity linked to morbidity and/or anxiety and frustration. It is something to be hidden and codified in order to keep the unknown far from our daily lives. Misunderstanding the history of man and fragmenting feelings and thoughts which, at one time, were part of a unified whole, we find concepts of death enveloped in an aura of violence and morality. The emotional instability of our times has created new myths of death which controversially find their way into the images with which we live. Damien Hirst's bisected calf is diametrically in opposition to the suicide bomber's feelings about death, but they both exemplify how death is visualized in

our global society. On one hand, the extreme evolution of the Enlightenment's faith in logic, rationality and science and on the other hand the Ancient Hebrew belief in a morally severe God who condemns fiercely the wrongs that others do while bestowing eternal grace on the chosen.

Without prolonging my condensed history of the abstract in art and its relation with death (I haven't even mentioned Freud's impact on the visual from Picasso to De Kooning) I'd like to consider our strange and sometimes morbid fascination with death in contemporary imagery. In fact, the concept of death has taken on more dimensions than it might prehistorically have had. Whereas prehistorically death was the end of life, or the absence of life, through history it became layered with new meanings. From submissive feelings of destiny and fate, death became a portal to somewhere else, to another world where people were better or worse off. A place where people acquired merits that were denied in this life, a place where ego's became eternal and therefore returned to an infantile omnipotence. Today's suicide bombers and teen-age serial killers are the victims of these ancient mythologies, further compounded by the daily semiotics of global consumption. All we have to do is contemplate The New York Times' web page commemorating the death of one of the victims in the Virginia State killings where the announcement, followed by viewer's comments, is juxtaposed with an enticing woman's stare imperatively telling us (while we contemplate the death of the Virginia Tech stu-dent) to "Get close to performers". We may think that we sepa-rate the two statements, but in reality our eye (and the impact on our unconscious) sees them as one.

Consequently not only has the reality of death changed for the privately, individually, it has also changed in the public's eye. Through photography, television and now on the internet, we are exposed to a quantity and quality of imagery of death which equals no other in history except, maybe, for the barbarian warriors at the fall of the Roman Empire who spent their lives hatching people to death day in and day out. Certainly, any-one caught in any historic tragedy (or social event, for example

the townspeople of Düsseldorf in 1240 who willingly saw 60 knights hacked to death in one day's tournament) has seen more than his due in murders. The Medieval experience was literally replete with violent death as Albrecht Dürer's woodcut of Cain killing Abel so clearly portrays (see frontispiece for this text). But today, we no longer have to participate in order to see things, we just have to click an URL and we are offered the horrors which few have been witness to. Almost imperceptibly, death has become synonymous with violence and violence has become part and parcel of our daily lives. No wonder contemporary art is so full of violence.

Like the unfortunate few caught in history's tragic moments, we submit, sometimes unwillingly, to visions of violence once reserved to the very few. From printed to transmitted news, we are force-fed daily violence which exceeds human understanding. We are forced to contemplate violence in unexpected moments and places. The Abu Ghraib images are a repulsively perfect example. Some say this is thought provoking. Maybe, sometimes, but just maybe. It is pathologically human.

My body was not designed to travel 300 mph without some kind of special protection and my mind is not prepared to see this amount of violence without some kind of special protection, it's just that I'm not quite sure what kind of protection I need. I'm not prepared to see headless corpses found in Mexico nor the body of a dead 5 year-old girl raped and bludgeoned to death.

Obviously, there is not only violent death. Art's depiction of death often deals with the unknown and the abstract. The spiritual aspect of returning to the stars has been subject of an overwhelming part of art history in any culture. I've no need to mention how much religious art is concerned with the final question. Photography especially has been involved with death from Roger Fenton's and Mathew Brady's realistic depictions of the dead in the American Civil War, through Weegee's documentation of murders during the 30's to Walter Schels' recently published imagery on life and death portraying cancer

patients before and after their death. But there is a more neutral, spiritual aspect which, I feel, worth exploring. The visual metaphor for death is rich in examples. Minor White, the American photographer, created an image of light playing on a wall near a window. A fascinating image of spirit, of life and of death but death in a very positive rejoining of the soul to the universe kind of way. A precursor of New Age before New Age had been labelled, White was always interested in spiritual revelation through photography.

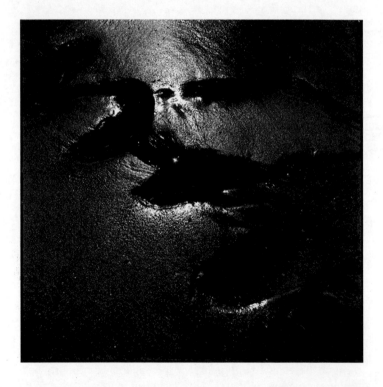

Another approach is the intense, painful and tortuous journey visualized in the work of Marianne Boutrit (see previous page). Her work is full of strength and suffering. Of scar tissue and painful growth. It is the visual metaphor of life in an intense

ordeal of growing and dying. The poetry of her images empha-
sizes the visual contradiction of suffering, therefore seeing life
as a tortuous journey to death. Not in a self-congratulatory way,
nor a self-conscious one, but in a poetic exposition of our vital
inner strife. Isn't that what art has always been about?

But I am forced to deal with violent death, senseless death,
martyrdom death, suicide, ethereal death, spiritual death and
transcendental death, just to name those that come to mind. We
see death as punishment, as a premium, as a reward, as a portal
to freedom, to happiness or to eternal shame. We die as victims,
patients, targets and just plain people. We die young, old, in
middle life, at the peak of our lives, as infants and even before
birth. Art, like the evening news, depicts all of this. Art tries to
help us, shock us, provoke us and console us. From Joel Peter
Witkins' intelligent images using death to speak about life to
the surveillance camera's recording of the teen-age suicide
killer, from Andreas Serano's young and beautiful meningitis
victim to Benetton's billboards posted throughout the global
economy of a man dying of Aids or the pervasive video games
which allow us to kill at random, we are surrounded by imagery
calling our attention to the final moment, to our last instant, to
what happens when our life leaves us. But the mystery does not
start there, it starts when life comes to us. Unknowingly we are
born. When the miracle leaves us or is taken from us, our ego's
disappear and we slip unknowingly back into the primordial
soup from which we all come. No television, no internet, no
violence, no art. Not having done that, I can look.

16

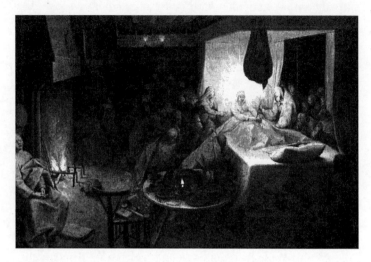

Brueghel the Elder, *Death of the Virgin*, circa 1564

WHEN TWO DEATHS BECOME ONE
George Pattison

In memory of Jean Pattison, 1921-2006

This article offers a short meditation on Brueghel the Elder's painting of the Death of the Virgin, a work that can be seen at Upton House, near Banbury in Oxfordshire. Part of the prestigious collection of Viscount Bearsted, heir to and for twenty years Chairman of Shell Oil, the painting opens up a world that is very different from that to which the modern oil industry belongs and offers a view of the human being that is very different from that which is reflected in the modern technological society nourished on Shell and other brands of petroleum oil.

As is typical of Brueghel, the painting takes a major topic of traditional religious art and treats it in a novel and even revolutionary way, transposing an event that belongs to the ecclesiastical canon of sacred art into the humble intimacy of what might well be an ordinary Flemish farmhouse. The room is dark, and, apart from the dying embers of the fire and three small candles, is illuminated only by the light shining from or perhaps from somewhere behind the frail figure of the Virgin herself, sitting propped up in a curtained bed. This light might be interpreted as some kind of halo, but it is only ambiguously supernatural: it is also possible to see it as the reflected radiance of the long taper that she is holding in her hands, which also lights up the crucifix placed on a pillow at the far end of the bed and on which she rests her gaze. On either side friends and relatives crowd round; on her right, a woman rearranges the pillow, on her left, a white-haired priest, bearded and wearing a cope, leans over and helps support the taper that her weak hands are unable to lift unaided (presumably this is John the Evangelist with whom, according to Christian legend, Mary went to live in Ephesus). Of the rest of those present, some are kneeling in prayer, one is holding a cross, while others stare in curiosity and awe. Outside the radiance of the natural/supernatural light around the Virgin, ordinary life goes on. A cat sits in front of the fire, beside which a woman, perhaps a maidservant, has

fallen asleep, while the array of objects on the table and the empty chair beside it bespeak the domestic needs and activities that must go on, even in the presence of death.

If it were not for the extraordinary brightness of the light that encompasses the figure of the Virgin that seems to come from a mysterious and perhaps mystical source (although, as I have said, this is ambiguous) this could be a very ordinary sixteenth century death. In many ways it is the epitome of what for many centuries was regarded as the good death, a death died at home, in one's own bed, conscious and awake, supported by friends and family, and with the spiritual encouragement offered by attendant clergy and a crucifix to direct the dying person's gaze away from this world to the world to come. In this regard it is very different from the death that most of us die in the modern technological world, in a hospital ward, probably alone, heavily sedated, and with every care taken to assure us that 'it's going to be alright' and 'not to worry', i.e. that nothing drastic or decisive is really happening and we have no need to be especially concerned about the alarming changes in our somatic condition. It is also very different from the paradigms of violent death that have so often been the focus of modern art, literature and culture, from Goya through Dix to Warhol, from the gunfights of the Wild West through the killing fields of modern warfare and on to the murders, suicides, and overdoses with which crime fiction, television drama, and film drip-feed their audiences. We have, it seems, almost forgotten that death can be good, and that it can be good to go to one's death in full and conscious awareness of all that is happening, and that religion can help us to such a good death. For Brueghel, however, even if this ideal is only imperfectly realized by many dying Christians, the scene he has depicted is one that would be familiar to him and to those who first saw his painting. If they had not seen this death, they would have seen deaths like it, and it would have fitted their expectations of what a death should be like.

There could be more to be said about our changing culture of death, about what we have lost (and, of course, what we might have gained), but my main interest here is not to take up arms

against our contemporary technologizing of death: rather, it is
to let Brueghel's picture lead us into a further reflection of the
meaning of this very specific death. In this regard, it is, in its
mundane simplicity, far more religiously profound than what
has become the conventional iconography of the event.

Although the dogma of the bodily assumption of Mary into
heaven was only officially promulgated by the Vatican some
sixty years ago, it had long been honoured in Catholic practice
(indeed, this was one of the arguments given in favour of au-
thorizing the doctrine). This practice included the visual repre-
sentation of the assumption, often a subject for altar-pieces or
for private prayer-cards. In the form that became standard in
the Counter-Reformation the artistic representation of the as-
sumption showed Mary, often returned to her youth, ascending,
apparently effortlessly, to heaven, sustained only by downy
clouds from behind which peeping cherubs gaze adoringly.
From Zurbaran and Murillo down to the collapse of their tradi-
tion in the kitsch of Bouguereau and his successors this was,
visually, what the assumption meant. However, apart from be-
ing an opportunity to paint a pretty woman and to demonstrate a
virtuosity in dealing with light and space, it is generally hard to
see why such a scene should be regarded as religiously signifi-
cant. In contrast to this now degenerate tradition, Brueghel's
picture not only offers us a more humanly recognizable ap-
proach to the mystery it represents, but his attention to detail
also identifies the key to its religious meaning.

I have noted that Mary's gaze is fixed on the crucifix. But this
is itself a plastic representation of the death of her own son,
Jesus of Nazareth, believed by Christians to be Messiah and
Saviour, 'the Way, the Truth and the Life', 'whom to know is
Eternal Life', as St. John's gospel put it (and, recall, it is John
who here attends the dying Mary). Of course, for a dying moth-
er to let her eye and her thoughts dwell on what must have been
the single most agonizing event of her life would seem scarcely
consoling. John's gospel itself places Mary at the foot of the
cross, and Christian art of East and West has also shown her
there, together with John himself (as the text also indicates),

Mary Magdalene, and other women and disciples (although
sometimes, as in the sculptural figures on rood screens, the
figures are limited to Mary and John). In the West in particular
artists were willing to explore the grief and terror of Mary in
the face of the appalling act of torture being wrought on the
body she had brought into the world. Often we see her not only
tear-stained but fainting, held up only by the surrounding disci-
ples (again, mostly, John and the Magdalene), as in Brueghel's
own painting of the Procession to Calvary of the same year – a
tradition continued in Pasolini's film of the Gospel According
to St. Matthew, in which Mary was played by the director's
own mother. She is even more prominent in the scene known as
the Pietà where, from Giotto on, she has become the personifi-
cation par excellence of maternal grief, offering some of the
most humanly searing images of the Western tradition, from
Giotto himself down to Käthe Kollwitz's memorial for the dead
of World War I and beyond: a terrible reminder of the cost of
all that man's inhumanity to man has done and does. Her grief
indicts every murderer and its impact does not need any expla-
nation of its religious or narrative context.

Brueghel, then, is not ignorant of the terrible human memories
with which the crucifixion confronts Mary, but, seeing this
scene again in the light of the taper held by John, he shows us
that she no longer sees it as the fruit of her womb being tortured
to death but as the gateway to eternal life – as Christians, taught
by John's gospel, also see it. But how can a person be delivered
from the trauma of such memories? Surely not just by the
teaching of a book? Surely not even by the testimony of others
that 'he was risen'? Christian tradition made of her the first
witness of the resurrection, and the gospels too count her
among the early witnesses – but that does not perhaps help
those who look to this picture for a guide to their own approach
to death. For in this instance, she then had a consolation that we
do not have: she had seen for herself what we can only see by
faith or 'in a glass darkly'. The question, then, is: what is there
in the story of Mary, apart from a direct and supernatural reve-
lation of the resurrection, that made it possible for her to move
beyond the trauma of watching her son die an agonizing death

so as to be able to see in the image of his death a promise of eternal life? What, humanly, can transform such horror into such hope?

To answer this question, I should like to move from West to East, more specifically to the representation of the death of Mary in the iconographical tradition of the Eastern Church. Both dogmatically and artistically this shows us something rather different from the bodily ascent or assumption of Mary into heaven. The icon is generally known as the icon of the dormition or falling-asleep of the Virgin. Typically, the scene is not depicted in such a way as to highlight the participants' emotional involvement or reaction but is represented in a solemn, hieratic manner (although some icons, such as those of the Stroganov school that can be seen in the Russian Museum at St. Petersburg, do invest the characters with an intense, if restrained, dynamism). What we see in the icon is the body of the virgin lying with hands folded on the open bed. At her head and feet the entire community of apostles is gathered, including both Peter and Paul. Behind her body we see Christ himself, holding what the untutored eye might see as a small infant wrapped in swaddling clothes (and, in the Stroganov icon, also – unusually – reaching out to touch his mother's head). The puzzling presence of this infant figure, so alien to the Western tradition, is easily explained. As Ouspensky puts it, 'He [Christ] is holding on His left arm a small figure of a child clothes in white and crowned with a halo: it is the "all-luminous soul" that He has just gathered up'. (1) The child is the mother herself, so that, visually, the icon offers an astonishing inversion of the mother/child relationship. Just as icons of the nativity show Christ himself similarly haloed and wrapped in swaddling bands, he now takes on an almost maternal appearance in relation to the 'all-luminous' infant soul of his mother. In a mysterious chiasm the mother of the Christ has become his child; the son has become mother to the mother's soul.

But how does this mysterious exchange answer our question? If we are no longer talking about the miraculous factor of resurrection appearances, we are surely in a realm of supernatural

exchanges of grace that pass human understanding? And yet, this is surely an exchange that is not essentially supernatural but at the very heart of the natural relationship of mother and child: that the utter care of the child by the mother inspires in the child an utter and entire obligation of care for the mother. This is not a matter (although, in some social conditions, it can become a matter) of merely external obligation, a social law imposed on the child. Rather, in the spontaneous and virtuous circle of love it is the epitome of original movement of love loving forth love in the other. In the particular relationship of Mary and the Christ, his death on the cross has been interpreted by the Church as his way of loving his own to the very end, whilst her presence at the foot of the cross – making herself see what no mother could bear to see – shows that she too loved her own to the end. What makes the chiasm of love between mother and child 'salvific', even in the presence of death, is the assurance and entirety of that love. In the face of the trauma of death, the circle is unbroken. Neither repeating the economy of a purely biological or social relationship, nor dependent on supernatural occurrences that are unknown to most human beings, the iconography of the crucifixion and the dormition – when these are read in dialogue – allow us to see, literally to see, the movement by which love triumphs over death. That these two deaths are offered by the Christian tradition as objects of devout representation and reflection, however, means that the possibility of such a triumph is not to be limited to this mother and this son. It is a possibility for all mothers and sons, parents and children, husbands and wives, friends and neighbours who are able to be with each other in their suffering and who love to the end. When two deaths become one in this way, where is death's victory?

Unfortunately, as I have said, the mainstream Western representation of the assumption entirely forgets and therefore entirely conceals this dialogue and the chiasmic force of the mother/son relationship in these two deaths. Brueghel too is very far from the Eastern tradition, and the way in which he domesticates the death of the Virgin and makes of it almost a very ordinary Christian death in a very ordinary country dwell-

ing, arguably distances him even further from the hieratic art of the East than the post-schism development of ecclesiastical art in the Catholic West. Yet the way in which he constructs the scene shows that he has well understood its theological significance, and he reveals this with a force that is not diminished by its entirely individual combination of simplicity, homeliness and intellectual subtlety. Even if our modern eyes have too often lost the focus that might enable us to see this significance, it is there to be seen in this dark, ill-lit room, where an elderly woman lies dying. Here too, if we have eyes to see, is the love that moves the sun and stars.

Notes

1. Vladimir Lossky and Léonide Ouspensky, *The Meaning of Icons,* St Vladimir's Seminary Press, New York, 1983, p. 214

THE ENDLESS SEARCH, THE ENDURING PRESENT
Sr Anselma Scollard OSB

Art: whatever is firmly placed, made of matter, existing in time; what we can see and touch. Death: what comes after temporal knowledge; what we cannot know. Are these two separate worlds or are they one? Is art, that which seems so present to us, really part of a world which is hidden from us? Does how we make art affect how we view death, and does death determine the art we make?

In this essay I would like to show how what may seem to be two worlds are actually connected and are but one, that art's objective presence forms a bridge between the present and the future, and what art is able to express concerning our present life is essentially of the same nature as that which we will know after death. Both art and death are concerned with the present moment, not the moment which is about to pass away, but the moment or moments when we step outside of time instead of being governed by it. Those *small* revelations which are given us in art are of the same nature as that final summation of these moments which will be revealed to us at the moment of death. Much of contemporary art however, rather than being an attention to the present moment, is instead a constant projection forward of the recent past, where the artist's expectation of fame and fortune creates a wall between himself and the work on which he is engaged. This *wall*, largely of the artist's own making, prevents him from interpreting the past and using it in the present and, as it were, moving towards the future. It is the result of an inattentiveness to the present moment.

The attentiveness to the given moment bears none of the hallmarks of the 'cutting edge' mentality. The latter, rather than showing an attentive awareness to the here and now, exhibits a grasping possessiveness, a *making my own* of something which precludes the essentially shared meaning natural to art. 'Cutting edge' art functions rather as a commodity does in the world of the consumer: *newer and better*. But the very nature of art eschews these temporally restricted divisions. The *visions* of art

transcend time, whilst ever being firmly rooted in it. There is an innate connection between today's relativism, which rejects the possibility of absolute truth and beauty and makes everything a matter of subjective taste, and the contemporary artist who views artistic activity as an occasion to flaunt one's own personal whims and fancies, what Picasso called "making a present of one's personality."

But what has the present moment to do with death, which until it happens always lies ahead of us? Death is the conclusion, the completion, the only moment which has no subsequent, the moment when one is immersed in the present of eternity. At death there is a total and complete awareness of all that has preceded. This complete awareness which death opens to us needs to be an instinctive attitude in the artist. In a sort of aesthetic paradox, the present moment is something from which the artist must abstract himself in order to be present to it. The situation of the artist is like that of a child at play. Time does not exist, it continues and the play becomes everything. It is not that the artist any more than the child can stand still, it is just that he is not concerned with other things in order that he can be alone with what he is doing. This is being present to the present moment, that state of being which death assures, but which seems so difficult to attain in our day to day routine existence. Death is the completion of life, it is not the end of life. It is the completion of all those individual acts, seemingly so disconnected but re-united in that final unending awareness, that moment the understanding of which constitutes the life of every human person. In death one sees beyond the accepted seeing to see something new made of the old. That is the seeing which is necessary to the poet and the artist. In this *artistic seeing* the artist, the poet, must see anew: the familiar must become unfamiliar in order that it may be seen anew. The artist must be removed from the present moment in order to see it more clearly.

This seeing is a kind of *abstraction*, a being taken away, a purification of sorts; and so the need for solitude in art as well as in life. It is a time for silence, that is, visual silence. The visual

world we live in has no silence, because it has no space. The artist has become merged with his environment to the detriment of both. Without this *visual silence* the artist can not be present to himself nor to his work. The work of art requires both that he be present to himself and to the world. An artist's complete absorption either in himself or in the world can only breed neurosis and sickness, and much of what we witness today is precisely that, only in a kind of ironic inversion. Contemporary art witnesses an artist's complete absorption in the world which becomes a projection of his own self. It is a lack of solitude which produces this forcing of the world's image upon the artist so that he can see only himself, but as the world would have him be, so that he sees neither himself nor the world, and so is unable to portray either. This diversion, distraction, or self-absorption ensures neither a presence to oneself nor to the world.

The artist must isolate himself — at least psychologically — from the habitual, which is often the most fashionable view offered by the world, including the world of the museum curator and art critic. This separation from the world is not that of the morbid melancholic romantic but a choice, even if an unconscious need, to be alone in order to see clearly and without distraction. But does the artist's self-imposed isolation really have anything to do with death, any consideration of which some might think to be both morbid and pathological? The isolation, ideally physical but not necessarily, if the artist is adept at screening out unwanted distractions, is actually a sign of artistic and spiritual health, a preparation. In death our isolation from the world will be complete, not the preparatory isolation necessary to the artist, nor one over which we have any control, but the complete separation which will enable us to have that vision of fullness, theologically referred to as the 'beatific vision.' This is not a *heavenly fantasy* any more than the artist's creative expression can be an expression disconnected from reality — although much of what we see today is just this.

Each artistic creation is made from something old but has become something new. It has left behind the old even as it may have made use of it. This leaving behind and entering into

something new is a kind of death, a death which is and must be personal. The end of the 20th and the beginning of the 21st century have seen much art which might be called 'personal,' but 'personal' in this sense has less to do with the individual person than with the projection of a subjective response to an accepted artistic milieu. Death can only be personal. No one can accompany us in our death, for when we come to meet God, and I believe this is what happens at death, it is the life of each person whole and entire that God wishes to confront, a confrontation which is an awakening for the individual, but not for God. Judgement is awareness. The personal nature of death is foreshadowed in each artistic creation where the artist too must stand alone and give account for the judgements that he has made in his work. It is not always conscious accounting, and in some senses it must not be. Art is not a matter of control, but it is something for which the artist himself is totally responsible. He cannot defer responsibility to someone outside of himself. His decisions can only come from himself, if they are to have any artistic integrity. To make what is wanted — art as *commodity* — is not the same as to make what is required, and this latter is a totally personal choice.

How else is art like death, death, which many identify with finality and end? Why does an artist continue to work if it is all to end anyway? Picasso said: "The artist never finishes," and yet there are finished paintings. The artist like everyman seeks to know. He is never satisfied, but differently from the way others are not satisfied. Lack of satisfaction does not necessarily mean *dissatisfaction* but it indicates a need, as it were, never to be finished. The artist must continue but he must not repeat himself (unless that repetition is to be part of the whole). Picasso noted that: "Repetition is contrary to the laws of the spirit, to its flight forward." If the artist always continues to produce the same thing his work dies, not as death before new birth, a completion and fulfilment, but as an end. The artist is one who cannot end, he must always continue working — to go outside himself in order that he may return to himself. This is an act of purification, a re-definition for himself and for his work. A work of art is always related to what has preceded it, but it must

never be static. It is always moving forward, longing, and mirroring the human soul itself. Rilke described the soul as "only having an inkling of what it achieves, speaking to itself in riddles." The artist cannot have a completely conscious *control* over his art; he often does not understand what he does, even when he realizes it is needful to what he is doing.

The longing characteristic of the artistic temperament (although this is often portrayed in a romantic and artificial way) "wrests (man) from the contentment of everyday life...it wounds him and this very wound gives him wings drawing him upward... beauty wounds but this is precisely how it awakens man to his ultimate destiny." The longing, which the theologian Joseph Ratzinger speaks of as a 'wound' is ultimately only fulfilled in God and is often experienced by the artist as frustration, a never being satisfied. It is part of the human condition, but in the artist it is a necessary requisite. The contemporary artist Anselm Kiefer speaks of painting, as of life, as "being a conglomeration of failings...[where] expectations are always unfulfilled." But he also speaks of painting as "a transformation which also transforms the artist." This transformation is the work of every individual. Its accomplishment can never be gauged in terms of success, for people are only successes and failures in terms of what is merely 'transitory' as Kiefer notes. The artist who seeks success no longer believes in the intrinsic truth and beauty of what he makes; he is concerned only with himself, and as an artist has failed. He has chosen the transitory and rejected the enduring.

The artist is often thought of as one who has the special ability to *imitate* (a significant word as it denotes something that is not real) and *reproduce*. He would be more accurately described as one who is able to see better or see differently. His restlessness, a part of his longing, the solitude he seems to require, his impatience with the routine, are the very things which allow the artist to see things afresh, to find the new hidden in the old. The understanding which every new work of art gives us is essentially an uncovering: it points to the future in that it is new, but is rooted in the past as being the uncovering of something

which retains the vestiges of the familiar whilst transcending them. It belongs to the present, it is a bridge between the past and the future, and as Ladislaus Boros puts it: "the creation of a new relationship with the world, defining as such a real proximity to the world; [yet] it thrives in existential isolation, supposing a withdrawal from the world as fundamental as it is unique, a separation no where else attained." But the *uncovering* specific to death is in its totality so fundamental that it might seem to bear no relationship to the unveilings ex-perienced in art. Art moves between these two worlds, the one totally hidden and the other apparent, or so it would seem, but in reality it is the artist's task to see and translate into a physical expression what is hidden in the temporal world. Boros describes the artist as existing in a 'frontier' position, for art is both concrete and transcendent, the manifestation of man's soul and body. Anselm Kiefer refers to painting as transformation, a movement across, through and beyond. Death is the culmination of many transformations. It is the final and lasting one made up of all the others.

But death is not finality in the sense of end, of closure, an eternal halt. It is rather completion, fulfilment, a consummation, a coming together. In contrast to the contemporary conception of death, which sees only finality and termination, the 4th century Greek Patristic St. Gregory of Nyssa saw death and indeed all of the spiritual life as perpetual progress. This *progress* must be distinguished from the present day scientific and economic notion. It is a progress in delight, an essentially evaluative term signifying an ever growing appreciation which never terminates. It is the delight of love, and being such can never denote the merely transitory. To describe this progress Gregory uses the word 'epectasis,' a Greek term meaning *tension* or *expansion;* that is, something which retains contact with what has preceded but which moves forward. Gregory saw life and death as one, or rather the latter as a continuation of the former. Man's transcendent nature is by that very fact never satiated, every satisfaction is an encouragement to something beyond. The term *eros* normally associated with physical attraction and possession becomes in Gregory, what one commentator calls "a

symbol of supra-rational attraction drawing the soul irresistibly towards God." The more inaccessible God seems, the more fervently is he sought. In a commentary on the Canticle of Canticles, speaking of the Bride seeking her Beloved in what is a seemingly endless search, Gregory expresses an attitude which could be applied to the artist, likewise engaged in an endless search. Picasso: "...have you ever seen a finished picture...Woe to you the day it is said that you are finished! To finish a picture? What nonsense! To finish it means to be through with it, to kill it, to rid it of its soul, to give it a final blow: the most unfortunate one for the painter as well as for the picture." Gregory: "The true satisfaction of the [bride's] desire consists in *constantly* going on in her quest and never ceasing in her ascent, seeing that every fulfilment of her desire generates a further desire for the Transcendent. Thus the veil of her despair is torn away and the bride realizes she will always discover more and more of the incomprehensible and unhoped for beauty of her Spouse throughout eternity. Then she is torn by an even more urgent longing..." The great French patristic scholar Jean Danielou describes this movement of the soul as "a yearning which fills the soul more fully than actual possession...[but this in turn] *displaces* the soul and forces it to centre itself on God in an act of total dispossession." Is this not the disposition which we should expect that art would effect in the artist?

If art is connected with death as an enduring reality, what can exhibitions which clearly do not present themselves as having any interest in objective excellence, but rather as personal display, indicate for the future of art, for our attitudes vis-a-vis the most fundamental of all questions, that of death, and for the death of one who calls himself or herself an artist? If the artist himself is replacing his work, and such would seem to be the case, if a statement in the Daily Telegraph of August the 5th 2008 can be used as an example, where the critic refers to one contemporary artist as having "become (herself) her most successful work of art," then art in its traditional sense as necessarily being an *object* has lost all meaning. In fact it no longer exists and has been supplanted by the cult of celebrity. The

artist who no longer looks beyond himself has given up that essential search vital to art.

But art continues to exist in spite of the spiritual blindness of those who call themselves artists, because the nature of art of itself is enduring, even if those who practise it are not. *For the eye does not tire of seeing...* Eccl.1:8. Art abides even as it tells us what we do not yet know, or as expressed in the terms of the spirituality of Gregory of Nyssa: "The soul of man moves ceaselessly upward always reviving its tension for its onward flight by means of the progress it has already realized...it does not slacken its tension by action but rather increases it." Death is the consummation of this endless search, while never placing a limit on it and thus forever fulfilling it. Art sustains us with the hope that tells of things we do not yet know. It is part of the endless search enduring forever.

Roy Oxlade, *V's Studio*, 2006

34

Roy Oxlade, *Persecution Pictures IV*, 1989

AND DEATH I THINK IS NO PARENTHESIS*
Roy Oxlade

Youth puts death into brackets. But as e.e. cummings said, death, sooner or later, must elude the parenthesis, as we always knew it would. The prospect of non-being is disagreeable. Caught reading the bible on his deathbed, W.C Fields, said he was looking for loopholes. Pascal like George Steiner takes the gamble on transcendence. It is said, there are no atheists in lifeboats.

With death matters, it is a commonplace to think that the artist has some kind of advantage, a comfort, an insurance against oblivion. The artist, they say, 'leaves something behind.' All artists die, yes, but the vast majority of them leaves a legacy of dead art. Our more or less noble attempts to join in with Mozart or Shakespeare are inevitably destined for the skip. In a hundred years time, assuming planet survival, a neglected skewed and sinking headstone will make a better epitaph than the stored remains of the tenth remake of a disordered bed.

On the question of being, humans have the advantage over art. To be born is to have being. It comes with the human condition. People don't baptise teddy bears as children, to find out only later that they are teddy bears. But stuff launched from the studio arrives with the implicit claim that it is alive even though inevitably, sooner or later, it is found to have been stillborn, the speed with which it gets buried and forgotten depending upon a number of factors, the major one being how critically acclaimed the artist was who produced the work in the first place. In the case of very expensive art by celebrity artists, vested interests ensure that, dead or not, a semblance of life is artificially maintained by a curatorial and business collaboration operating a global and dubious life-support system guaranteeing market stability. Unlike humans whose capacity to die depends upon having had a life, we come to see, taking the long historical view, that most art, whatever fame and special protection, it may temporarily have enjoyed, has not been art at all, its baptism, a charade.

The mounting confusion about the nature of art and the perennial issue of aesthetic criteria, together with profound economic and environmental problems with which they are closely linked, is now increasingly, if belatedly, becoming the focus of critical attention. The obvious is now being accepted: that the decline in our ability to recognize dead or non-art for what it is – failed junk, has been inversely accompanied in the twentieth century by a vast increase in its output. But the rot had set in at the turn of the century, at the very time of art's emancipation from external constraint. Society's aesthetic failure has been, not unexpectedly, in tandem with environmental degradation.

Given the growing mood of apocalypse in all areas of thinking society, it is not surprising that it will find expression in the work of artists who see their role as one which reflects the condition of the world. But representations or symbols of catastrophe are incidental to the making of art. Art cannot lean for its authenticity upon the artist's response to portentous events. Not every crucifixion is a Grunewald; and conversely political accommodation does not stand in the way of composing a masterpiece, as in the case of Mozart's *The Marriage of Figaro*, its libretto trimmed to calm establishment nerves.

Potential disaster and eventual death are the accompaniment of all life. Any human action is made in defiance of mortality. To varying degrees, we have all fiddled while Rome burned from the time we were born. But if the arts have been especially given to vacuity, it may be entirely due to the fact that even attempting to produce art is a huge gamble: if masterpieces are few, as Gertrude Stein said, then most artists have to fail.

What is successful art? Without expecting an answer we shall go on questioning the validity of our subjective convictions about the value we ascribe to particular art works: the ones which, for us, live. The existence of museums and libraries had always seemed to support the notion that far from being a lonely solipsistic encounter, an appreciation of the arts implies belief in the existence of a criterion, however elusive. Distance from the date of its production increases the possibility of con-

sensus about art's value, and with historical perspective, masters and masterpieces become established. But any shared, safe ground achieved is limited to what is easily measurable: technical innovation, antiquity and sale room price. Agreement about aesthetic value, especially in the visual arts remains problematic. Yet, it can be argued that having aesthetic value is the necessary condition not only for art but for a satisfactory environment. In the absence of the aesthetic dimension the possibility of art dies, just as without an aesthetic *conscience* you can kill off the landscape by cutting off the top of a mountain to tear out its coal.

Published provocatively without a question mark, *'What Are Masterpieces and Why Are There so Few of Them,'* is one of Gertrude Stein's most brilliant essays. Here, the masterpiece for Stein is not limited to the large canvas, a Vatican ceiling or a Ninth Symphony, but scale an irrelevance, her concern focuses on that rarity, the authentic work of art. There are few masterpieces because few works intended as art succeed; and they fail because they are extensions of identity and thereby cannot achieve the goal of entity. When an artist is deeply conscious of herself and her subject, when she *thinks*, then, in Steinian terms, she becomes an identity – and so does her work. On the other hand, for Stein, a masterpiece lives as an entity: a disinterested thing-in-itself.

Art born from a resolution of the paradox of knowing and yet not knowing, arrives rarely. It is difficult to make work which depends upon forgetting or transcending the intention which must precede even its being started. Any successful art is a triumph over deliberation. As Stein says there are few masterpieces. The paradox is made more intriguing by the activities of artists who do not make things in any traditional sense, but who instead, designate, select, draw attention to, aspects of the natural world, or who transform otherwise ordinary mundane objects or spaces by installing them in an art context. These artists may possibly, in some instances, more easily circumvent the problem of identity, but the question of whether or not they should be considered artists at all, arises inevitably. From a

Steinian point of view, if artists are to be defined as people who make things out of raw materials, then the non-makers might better be categorised as demonstrator-aestheticians rather than artists.

However it is to be arrived at, art aims to create forms which when read, looked at, or listened to, transform the mundane. Since it has no 'material' justification, art is like a higher order game; it exists disinterestedly. When it succeeds, it moves life up a gear; its effect is to affect; it transcends daily life and within its milieu humanity is liberated; and because art is inert potential only until resurrected by human apprehension, the liberating process is interactive. Art has a life only in the awareness of human beings.

Few masterpieces: lots of dead art; and a lot of dead art seemingly appreciated by an increasing audience unconcerned that a dead art work is not a masterpiece. If that is the case then there are vast numbers of people suffering from what R.G. Collingwood termed *a corruption of consciousness*. Also, from a critically moral standpoint, I.A. Richards wrote "Bad taste and crude responses are not mere flaws in an otherwise admirable person. They are actually a root evil from which other defects follow." Richards believed that should art disappear, "a biological calamity of the first order will have occurred..." (See *The Principles of Literary Criticism*). Given the present danger to our whole global environment, the philistinism of Richards's 'otherwise admirable person' should more suitably, be applied to the collective – a reckless and philistine society. What Richards feared in 1924, Arthur Danto and others have already announced: art is dead. So what *is* the contemporary art which increasing numbers of people are flocking to see at art museums, if it's not art? The answer is, anything at all which museum theorists have decided to call art, from empty rooms to rooms full of identical boxes; from casts of anything, to helter skelters; sometimes even paintings, and they, like the other exhibits, are selected on the basis of their market success. But before we pronounce Richards, Leavis and the elitism of the New Criticism as hopelessly outmoded, we must not forget the

growing note of confusion and despair which despite their own complicity, is now being voiced by contemporary critics about the general condition of Western culture. Tracy Emin's tent is closer to Reality TV than it is to a Picasso or a Titian as well as being a clear example of Gertrude Stein's *art as 'identity.'*

Can art as we have valued it survive in this time? Theorists like Arthur Danto are sanguine about its death; a theorist can spin words about anything. By contrast, a wiser voice like George Steiner's laments, but is resigned to, the loss of *poesis*. (For Steiner the word poetry is too limiting; *poesis* embraces all the arts.) And he is right that Duchamp marked "the end of the concept of poesis as it has prevailed since antiquity." Steiner's disdain is clear. "What is labelled 'art' will continue to be produced, exhibited and enshrined. There are enough soiled sheets and bisected calves to go around." What now excites our curiosity in the art gallery will illustrate the "melting-down of transcendality...the 'masterpiece' as we have known and dreamt it cannot, in honesty, do so." And Steiner ends the penultimate chapter of *Grammars of Creation,* with one short bleak sentence, his French emphasising regret. "C'est fini la peinture."

It is difficult to find an alternative optimism to Steiner's conclusion. The embodiment of creative intuition in works of art, that is in art as *poesis*/poetry, on anything other than an isolated and dispersed scale will depend entirely upon the extent to which individual subjective value judgements can become a confident sharing of subjectivities. Given the complexity of the field both historically and currently, there seems little hope for this outside a total collapse of the market system and the consequent rebuilding after chaos: a forced return to a primitive, or more ascetic pattern of living.

So is art dead? A shared language of drawing is perhaps the most easily available and therefore the most promising direction in any search for a sound aesthetic in art. As with the environment – simple will be the best. A traditional aim for artists has been to reconcile parts within a satisfactory whole. Making and understanding a log fire has something metaphorically in common

with this. Like its components each fire is unique, yet to burn well not only do the logs need oxygen, they must relate to each other according to the same 'architectural' laws. All log fires are different and the same. While we continue to concentrate on theorising about what drawing means in terms of what it illustrates, we shall continue to lose sight of its aesthetic language, its 'architecture.'

So what should be the subject of drawing? Less our concepts and more our perceptions of the things around us, our lives: things, trees, houses, cats, people.

The success and attraction of so much transient or ephemeral art, like the 'art' of children, primitive cultures, graffiti and so on may be because its charm or magic has the quality of the natural over the deliberate. The very intention of setting out to make a "work of art", a masterpiece, introduces a self-consciousness which stifles the creative act.

Bird tracks in the snow, aircraft vapour trails are flawless precisely because they escape the potentially dead hand of intention. We appreciate them for their aesthetic value but they are not art. They may however provide a rudimentary beginning for a shared critical language. The link with nature both for art and for survival, however temporary, is vital.

*e.e.cummings, from the poem *since feeling is first*

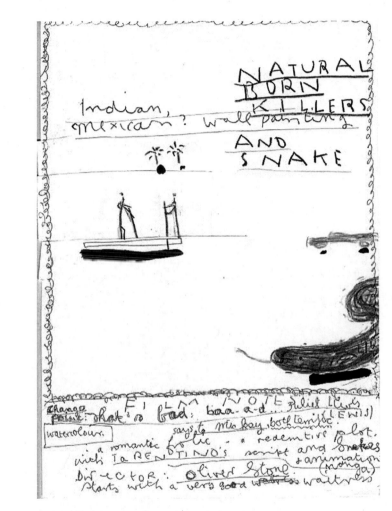

Rose Wylie, *Film Notes, Natural Born Killers*, 2008

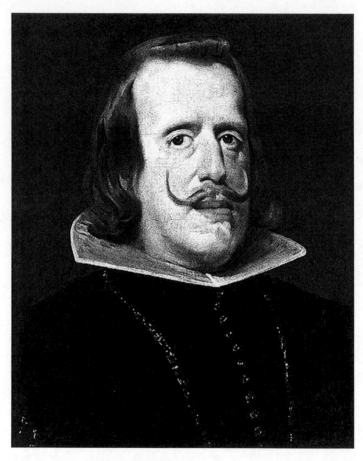

Diego Velasquez, *Philip IV of Spain*, 1656

SNAPSHOTS: VELASQUEZ'S PHILIP IV, BUTCHERS' SHOPS AND BACON'S PITY
Piers Faccini

I'm looking through a pile of old photographs and as I rummage through these assorted images from out of the pile one in particular grabs my attention. It's of a young woman staring directly at the camera, a smile playing behind her eyes. She's lying on a bare mattress propped up on one elbow. Behind her the wallpaper has been stripped back to the bare plaster, a few shreds still remain glued to the wall. In the corner of the frame a painting hangs on a small nail. Staring at the photograph I'm overwhelmed by waves of memories, drowned for several seconds in moments I'd long given up to a ghostly past.

I took that photo many years ago, the woman in the picture was staring at me, we were lovers at the time. The description above is a familiar scenario that we all experience in our lives each time we come across the various instalments of our past existences that we possess in the form of letters, photographs or mementos. These images often lie dormant for years until every so often they pop up from the shadowy recesses of memory. The scene that I described is one we all know – substitute the image of the lover for one of a lost parent, for a childhood friend or a sibling. The variations are both endless and universal and they illustrate the power that certain images have over us when we have invested them, or charged them, with signification. They need have no artistic merit whatsoever, their power lies merely in the charge they carry for the individuals involved who will, years later, still recognize the details of that snapshot's symbolism and colour in the gaps.

I'm mentioning this episode to show how familiar we are with the everyday passing of each moment we live, for as one moment dies so another is born. The continuity we are able to piece together to create the semblance of a life is merely the work of memory, and our memories are themselves just a grand slide-show of dead frames. The light of our attention allows us to relive this slide-show each time we are triggered by chance

or circumstance into doing so. Images of people, places and objects from our past are the most poignant reminders we have of our own mortality and of the impermanence of our lives. It's as if the subtext to each image were intoning, 'earth to earth, ashes to ashes, dust to dust.'

The painter Francis Bacon once spoke of his pity for our inescapable condition as meat, or as eventual carcasses. He described being overwhelmed by this in butchers shops standing in front of all the violet red hanging slaughter. The pity he spoke of was the ancient and noble emotion rooted in the paradox that is our essential condition as meat and our immaterial nature as spirit. When Bacon coined the defining phrase 'the brutality of fact' in his conversations with the critic David Sylvester, he referred to the Spanish painter Velasquez as the greatest exponent of this paradox in the history of painting. The *fact* that he speaks of is in many ways just another word for *truth*, implying the apparent impossibility of a non-subjective reality. Unlikely as that may seem, there is something miraculous about the great Spanish court painter's work, as if the paint itself has imbibed the soul of all that it describes before working itself into the canvas. It's as if the essential perceptual nature of each object described had been caught bird-like in his nets. Velasquez captured his sitters with the skill of a hunter, eventually to become no more than stuffed reminders of the hunt, hanging on walls as trophies looking so life-like and yet so utterly bereft of breath and life. Brutal like a hunter and cold like fact, as truthful as a mirror and as undeniable as a reflection.

There's a small portrait by Velasquez in the National Gallery in London of Philip IV of Spain that epitomizes beautifully Bacon's axiom. I became obsessed with it several years ago. It combines tenderness and cruelty all in one frame. It's the painterly equivalent of a sombre requiem paraded before our eyes. It reminds us of our impermanence, howling with despair and melancholy, its flowing brush marks undiminished by time, by fashion and change. There is something almost shamanic about Velasquez, as if he had decanted the essence of his subject and blended it into the oil, capturing the soul of the sitter, the soul

of the cloth he wore, the soul of his skin, the soul of the light that shone that particular hour, day and month in Madrid. It's no surprise Bacon loved Velasquez. This portrait is loaded with more pity than anything Bacon produced in his own portraits of his friends and lovers. Great as these paintings are, they are pale shadows in comparison.

This small and easily missed painting is able to transcend the centuries because it exposes with such eloquence this universal paradox of the spirit within flesh. Despite its brutal realism it tears at the heart, calling us to pity and love this man and his life that has passed as we would pity and love ourselves. Gazing at this work we become like Bacon weeping before the hanging meats. Standing in front of it feels like an audience with an undeniable truth common to us all, and it's all the more extraordinary that this could be expressed so clearly in a medium like paint, so personal to the hand that holds the brush and yet so objective in portraying a universality that binds all of our individual histories together.

Can there be a link between the snapshot of the lover and Velasquez's masterpiece? The emotions they produce in me seem to cross even though they are poles apart. They seem to bring about the same feelings in me of pity, nostalgia, reverie, love and loss. The snapshot of the ex-lover contains its own hard-hitting effect despite its artlessness, but it only strikes me because I can decode the various elements within the photograph – given my personal involvement in that specific scenario. Looking at it through the looking glass of memory, I am able to instantly create a whole story to accompany the image, but ultimately it's the story that the image carries for me not the image itself which is moving. The image itself is merely a means to an end and ultimately superfluous.

With the case of the portrait of Philip IV, it's almost the exact opposite. The genius of Velasquez is to bypass the need for us to know anything concrete or biographical about the sitter in order to be moved. 'Here is a man who lived and then died,' it seems to say, 'are you so different?' When contemplating this

work we are brought home to this truth, taking us from a personal to a universal dimension. Change a nose here, an eye there, swap one kind of clothing for another, that time for this time, and Philip IV is no different, say, from the guy I stared at on the bus this morning. The miracle is that all this is rendered in paint and written out in silence. Something has been caught in paint that is so uniquely personal and particular to one moment in history that it spins out the other side and becomes true to all time. It shows us in essence what it is to be human. In the end, both in the snapshot and in the Spanish master's canvas, the *brutal fact* that remains is the undeniable loss of the present and the passing moments sequentially placed together we call our lives.

Francis Bacon, *Dog*, 1952

Nazi interrogation room, 1944

VARIETIES OF DEATH: A 20th CENTURY PERSPECTIVE
Antony Copley

A Guardian reader (21 August 2008) by way of rejoinder to
Peter Conrad's Pauline conversion to Damien Hirst's *The Phy-
sical Impossibility in the Mind of Someone Living* had this to
say: 'Imagining death is at the foundation of all religions and all
great artistic traditions.' Mozart believed that the meaning of
life was found in death. Rainer Maria Rilke lived his entire life
as a preparation for death. How might this generalisation be
true of art in the 20th century? These reflections will explore
that question through overlapping themes, the medieval concept
of the good and bad death, the differing approaches of a reli-
gious and secular art together with the tensions between the
religious and the spiritual, and the teasing question, just how
differently does the 20th century artist confront an individual
and personal death as opposed to the collective. The exemplary
material has necessarily to be highly selective.

In the middle ages it was possible to off-set a good death a-
gainst a bad death, one prepared for by prayer and good con-
duct, one's further path through purgatory and onto paradise
smoothed initially by a carefully orchestrated burial and then by
prayers in chantries for one's soul. Where there was no such
preparation and death came unexpectedly through violence or
sudden death there was a bad death. Here was short shrift,
someone given too little time for confession and preparation for
death. In the 20th century the chances were horribly skewed
toward a bad death. It was a century in which millions were
denied all dignity in dying through the horrors of trench war-
fare and the crimes against humanity of totalitarian systems.
It was a century in which the private was increasingly dwarf-
ed by the public. In a post-Christian culture was it even possible
to imagine a good death? In the 19th century it had still been
possible to conceive of death as ennobling and there remained
a huge emotional investment in death as a rite of passage. But
in the 20th death became symbiotic with mass murder and in-
creasingly taboo. Was it indeed possible for the artist to differ-
entiate between a personal death and the collective, let alone

one between a good and a bad death? It is a challenge that faces us all. Do we instinctively approach the death of those close to us any differently from how we confront death through some public disaster, be it a natural disaster such as the tsunami or famine or mass murder through a political agency?

In my experience of death none caused so much grief, more than the death of a parent, than that of B.K, a long-term and intimate friend. Yet here was to be an exemplary death, one made possible through chemotherapy dispensing one more year of life in which to prepare for death and at the end, through the intervention of palliative care, being spared the indignity of pain. It was of course appalling to witness the nausea brought on by chemotherapy though here there have been striking improvements. It was pitiful to witness a once strong and well-built man deal with weakness. Once admitted to hospital, Brian could hardly believe how difficult it had become to carry out even the easiest of physical tasks. Could I find any words of consolation? It could not be a Christian consolation, although Brian and his wife Ivy had once attended a spiritualist church and he was not hostile to religion. I fell back on the wonderful idea in Philip Pullman's *His Dark Materials* where his heroes Lyra and Will journey through Hades, cut an escape route through its enclosing envelope, so allowing the souls to escape and then dissolve into the natural world of the air and sky and so into eternity. I also like to think it was I who first detected that Brian had reached the point when morphine was required to deal with the pain and got the palliative nursing staff to insert a morphine drip. One of the worst moments was being alone with Brian in the chamber of rest in the mortuary, his frozen corpse still beautiful but pitilessly telling me I had lost him. I was glad I had a chance through a personal address at his cremation service to honour his life but speech failed me as I said farewell that awful moment when the coffin slid away. But here was a death to admire.

One of the more morbid consequences of the way the world has opened up to us through the ease of international travel is that we can readily visit the sights of the 20th century's human

catastrophes. Here we are confronted by the very different circumstances of mass death. Like many, I have visited the battlefields and cemeteries of the western front, the concentration camps of Struthof in Alsace and Therienstadt outside Prague, the death camp of Auschwitz (but no camp within the Soviet gulag), the fire-bombed Dresden and the atomic-bombed city of Hiroshima. But none exercised such a peculiar sense of horror over me as the Plotzensee Prison Memorial, situated between the boroughs of Charlottenberg and Weddin in Berlin. Here 89 of the 200 convicted of the attempt to assassinate Hitler in the Stauffenberg bomb plot of 1944 were hung on meat hooks, this gruesome murder filmed for later viewing by Hitler. I also had occasion to visit the Wolf's lair in Eastern Prussia, Hitler's Eastern bunker, where Stauffenberg had planted the bomb. The sense of intense evil in this darkened space was palpable. It seemed wholly appropriate that the attendant in charge was blind drunk. Here I encountered the total degradation of death and one that sadly blotted out the courage of those good Germans of the German resistance. And here is the terrifying question: how can art in any way do justice to these victims of man's inhumanity to man?

Was 20th century culture equipped to address mass death? Freud in *Beyond the Pleasure Principle* and *Civilisation and its Discontents* postulated a culture that was under such a burden of repression that it was always in danger of breaking down into a longing for death. Jung read it differently but, in an even more germane way, explored how modern art could grapple with evil. He discounted Freud's attempt to explore the dynamic of the creative artist in terms of a personal repression (probably unfairly) and insisted on a distinction between the possibility of the psychologist trying to explain the creative process and the impossibility of the psychologist coming up with any explanation of the work of art itself. Despite the caveat on his own limitations, however, he proceeded to see in the collective unconscious, an alternative as he saw it to Freud's personal version, the source of primordial archetypes or symbols which transcended cultures and time. But each culture accessed the collective unconscious in its own unique way and

Jung believed contemporary culture — still in his view steeped in the middle ages and sentimentality — would dredge up symbols that would challenge that sentimentality, images visionary and irrational, 'glamorous, daemonic and grotesque,' 'a terrible tangle of eternal chaos.' 'Far from his work being an expression of the destruction of his personality, the modern artist,' Jung believed, 'finds the unity of his artistic personality in destructiveness.' (1) It would seem that the 20th century artist was in fact peculiarly well-equipped to confront the horrors of the holocaust and the gulag.

Jung's cross-reference to the medieval was entirely apt for in the late medieval period culture was equally confronted by the prospect of mass death. The Jewish scholar Millard Meiss in his *Painting in Florence and Siena after the Black Death* (1951) saw clear analogies between the post Black Death art of the 14th century and that of mid-20th century Europe. Paul Binski in his *Medieval Death: Ritual and Representation* (1996) read into late medieval Italian painting both a somatic or body centred art and 'an awestruck transcendentalism.' But in northern European culture, more as a consequence of a culture of guilt, in contrast to the Renaissance ideal of an integrated body, there were to be 'powerful and characteristic images of disintegration, the exploration precisely of the accidents of death.' Hell was seen as 'a state as much as a place of utter egotism,' an inversion of the divine order, and yet, and here there was a perverse possibility of black humour, 'its almost carnivalesque character,' for Hell was a place of variety and fantasy and 'as the sphere of the ego was the ideal sphere of the artistic egotism; it was wrong but it was romantic.' (2) Certainly images of the monstrous paintings of Bosch and Grunewald horribly anticipate the actual horrors of the trenches and the camps of the 20th century. Could the 20th century artist inherit that ironic even playful detachment?

Does music convey death more persuasively than painting in the 20th century? Of course 19th century opera carrying on into the 20th almost had its *raison d'être* in those histrionic and improbable death scenes. Possibly 20th century opera dwelt less

on the heroic, more on the squalid deaths of murder or suicide, a reflection of the times, but opera and death are inextricably linked. One claimant for an affective instrumental evocation of death is surely Richard Strauss in his late works *Metamorphosen* and *The Four Last Songs*. Thoughts for the first were prompted by the bombing of the Munich Opera House in 1944, and it was catalysed to completion by the bombing of the Vienna Opera House in March 1945. The piece, initially for 23 solo strings, was composed between 13th March and 12th April. Here is Strauss's lament for the death of German culture as he knew it. If the music suggests some initial struggle with this catastrophe, increasingly it takes on an air of resignation, a kind of Buddhist tranquillity, exactly what Schopenhauer was looking for in music as a conduit of the Will or the Divine. The latter were finished in May 1948. One inspiration was Eichendorff's poem *In the Sunset,* about an old couple who staring at the sunset ask , 'is this perhaps death?' The other poems are by Hesse. All this reflected the experience of Richard Strauss and his wife Pauline, holed up in a hotel in Montreux at the time. One music critic writes: 'No suggestion of religious consolation, even *in extremis*. The beauty of the world and the beauty of the female voice were uppermost in his thoughts to the end. Has there ever been so conscious a farewell in music, or one so artistically so good?' (3) Could artists rival such poignancy?

Another composer, Vaughan Williams, even managed to write music that celebrated a good death. It is in *Valiant for Truth*, his powerful setting to music of the words of Bunyan's *Pilgrim's Progress*. Mr. Valiant for Truth summons his friends to tell them that his pitcher is broken and that the time has come for him to go to his Father. He hands over his sword and his courage and skill to others to be a witness to his own battles. He confronts his death: *Death, where is thy sting? Grave, where is thy victory?* And here the music is exceptionally moving: 'So he passed over. And all the trumpets sounded for him.' Strange that an agnostic should write so powerful an evocation of a good death.

Is religious art better equipped than secular to portray death? It is one of the strange features of art in the secular 20th century that a Christian iconography remained so important a vehicle for both painters and composers, for was this not in a post-Christian age an exceptional opportunity to turn to a new iconography? Yet confronted by the omnipresence of death it was probably inevitable that artists should fall back on a tradition in which scenes of the Passion and Resurrection and Martyrdom endlessly dwelt on images of death. But the distinctive aspect here is that death is not final, there is the possibility of resurrection. One can here debate whether artists were but reflecting a religious tradition or tapping into a more personal experience of spirituality. I would argue that religion and spirituality are differing phenomenon, the one appealing to man's need for the liturgical and sacramental and a sense of the authoritative, the other an entirely more open-ended search for the transcendental. They can converge and do so in say the music of Messiaen. The downside of the merely religious is that it will cramp creativity. The risk of spirituality is that it will move into the dark side. I feel in listening to the late work of Stockhausen I am being threatened by a dangerous and perverse occult.

Two British artists, Stanley Spencer and Graham Sutherland, in a rich tradition of religious painting in 20th century Britain, addressed death in the two world wars. In the cycle of paintings in the Sandham Chapel at Burghclere in Hampshire, Spencer sought a personal healing from his experiences of the sick and dying of the Beaufort Hospital in Bristol and the experience of battle in Macedonia. Spencer was something of a religious pluralist — lost his early Anglican faith, passed through a Catholic phase, turned to Hinduism, Buddhism and Taoism — and so the great painting cycle in the chapel in no way reflects a doctrinaire Christianity. 'The Holy Box' as he named the chapel was inspired by the Arena Chapel in Padua and Giotto's fresco cycle, but significantly Spencer chose to highlight Resurrection rather than Crucifixion. Quite deliberately Spencer plays down the gruesomeness of violence against the flesh. He had confronted death all too frequently both in the hospital — and his drawing the injured and the dead was possibly the initial

inspiration for the Chapel — and on the battlefront as a stretcher bearer and a burier of the dead. But his was a redemptive view of death. Curiously he felt little bitterness about the war. His soldiers are seen 'as blissfully unaware of the dystopian world of war.' This was not to be 'the banal, disgusting death found in Remarque and Sassoon' but 'death that transcends death.' A rare *memento mori* in the cycle were the mosquitoes on the top of the tent in his *Reveille*; malaria had killed Lieutenant Sandham and had been a serious risk for troops in Macedonia, Spencer himself a casualty. For Spencer, Armistice day was experienced as one of transformation and running through the cycle of paintings in Sandham Chapel is a theme of transubstantiation, of bodies moving from death to new life. (4) Had Spencer flinched from painting the true horror of war?

In contrast, Graham Sutherland, a convert to Roman Catholicism, was wholly committed to his Christian faith. He had no direct experience of war and encountered death as a war artist of bombed cities. 'The bleakness of the atmosphere of war,' he later recalled, 'was like the prospect of death and more and more funereal.' Nor did he visit the camps though it was to be photographs of the holocaust that profoundly influenced his immediate post-war art, the Thorn pictures and the Crucifixion. They resonate torture and barbed wire. Yet one has to ask, why do these paintings lack the intensity of the earlier mystical paintings of the Pembrokeshire landscape and reflect a falling away of his creativity? Geoffrey Grigson at the time felt Sutherland had surrendered to the spirit of the age rather than transcended it: 'If this is an evil time and a time of the prevalent wish for death, that is no great reason for surrendering to a deathly admiration for its expression either in language or in paint.' In fact, Sutherland had absorbed Freud's idea of a conflict between Eros and Thanatos and hoped to reflect that tension in his painting. (5) Possibly Spencer's highly personal spirituality had got in the way of his communicating the true horror of war whereas Sutherland's constraining faith had reflected that horror but without any transcendence.

How differently do the non-believers deal with personal and collective death? No modern artist became so absorbed in human frailty and death as Edward Munch He probably felt closer to death than to life. 'We experienced death when we were born — we have yet to suffer the strangest experience; the true birth called death — but to what?' he queried. This was in 1932. His were to be extraordinary paintings of sickness, his *Self-Portrait: Man with Bronchitis* (1920), Munch himself a victim of the Spanish influenza epidemic of 1919, as one example. Following Norway's occupation in 1940, Munch's paintings in the last four years of his life were increasingly preoccupied with loneliness and death. There is the bleak *Self-Portrait between Clock and Bed*, the clock with no hands, the bed a reminder 'of the place where most people are born and die.' Most haunting of all is his *Study for Self-Portrait: Quarter Past Two at Night* (1944), Munch unable to raise himself from his chair, a poignant recall of the death of his sister Sophie in 1877, expressed in his *The Sick Girl Rises* (1907-8). There is a resignation here that matches Strauss's *Metamorphosen.* Here are studies of extreme human frailty that compare to Michelangelo's drawings close to his own death of the Crucifixion. They also strangely evoke those etiolated statues that Giacometti was beginning to work on at the same time. (6)

Luc Tuymans stands out as an artist who has dared to paint the horror of mass death. He has done so fully aware of Adorno's scepticism on the possibility of art addressing the Holocaust. Of course the artist is under no moral imperative to reflect contemporary events. Matisse, for example, despite his mother and brother being caught behind enemy lines in the First World War, and his estranged wife Amlélie being imprisoned for working with the resistance and his beloved daughter Marguerite being both imprisoned and tortured and lucky to escape deportation to Ravensbruck, refused to reflect the circumstances of either war in his work. Tuymans does not see himself as illustrator or chronicler but as a historian of memory: 'My paintings are a form of mnemonics — it's as though they're constantly "reconstructing" themselves, and have their own memories.' His is a painting which accepts the limitations of

art, working through understatement and quietude. It's intriguing that he has such a high regard for Edward Hopper's painting. The art critic and novelist Ian Sinclair made the fascinating observation that the characters in Hopper's paintings are in a state of limbo, dead, though with that exceptional quality of light flooding into the paintings, there is the promise of redemption. Tuymans is taken by Freud's idea of the uncanny and tries to suggest the eeriness of the familiar, by means of detachment, bloodlessness, by what he calls 'indifference,' to suggest the eeriness of the familiar, a sense of foreboding. And what could be more uncanny than a Kafkaesque bureaucracy dedicated to the implementation of death? All is oblique. In *Recherhes* he paints seemingly banal objects from the Museum at Auschwitz, in *Our New Quarters* he suggests the appalling ambiguities of Theresienstadt, not itself a death camp but a transit one to Auschwitz. The most insidious is *Gaskamer*. Titles are important to Tuymans and but for the title this might be a painting, one critic suggested, of a castle cellar. In its utterly washed out quality it might be painted with stain rather than paint and this points to another of Tuymans's foibles, of making paintings as if they were 'an authentic forgery.' Yet behind a bewildering estranged reality there lies violence. Here is a painting utterly purged of any humanity but yet, as viewer, I felt the same experience as I had at Plotzensee, of a terrifying evil and the complete degradation of death. (7)

Notes

1. Carl Jung, *The Spirit in Man, Art and Literature*, Routledge, London & New York, 2003, p.138
2. Paul Binski, *Medieval Death: Ritual and Representation*, Chapter 4, Cambridge University Press, Cambridge, 1996
3. Michael Kennedy, *Richard Strauss*, Dent, London, 1976, p.217
4. Paul Gough, *Stanley Spencer: Journey to Burghclere*, Sansom & Co., Bristol, 2006

5. Martin Hammer, *Graham Sutherland Landscapes, War Scenes, Portraits 1934-1950*, Scala Publishers, London, 2005
6. See *Edvard Munch 1863-1944,* Royal Academy, London & Bradford, 1974 and *Edvard Munch by Himself,* (published for Royal Academy exhibition), Cloister Press, Cambridge, 2005
7. Emma Dexter and Julien Heynen, *Luc Tuymans*, Tate Modern, London, (catalogue for exhibition 1 October – 11 December), 2005 including Julien Heynen interview with Luc Tuymans, 13 Januray 2004, Dusseldorf, translated from the German by Fiona Elliot

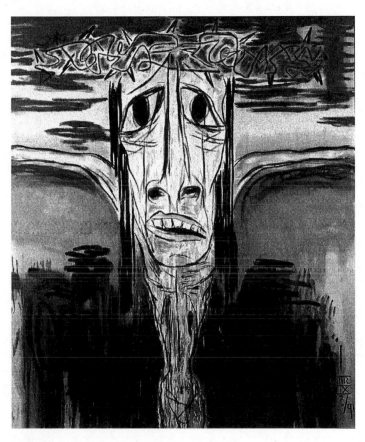

Marcus Reichert, *Crucifixion IX*, 1991

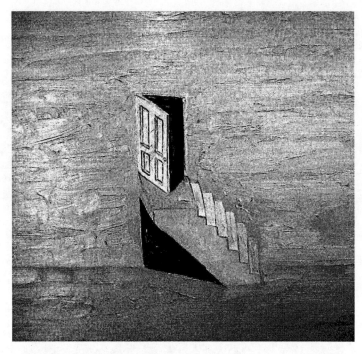

Stephen Newton, *Stairway to a Door* (detail), 2001

SPIRITUAL TRANSFORMATION
Donald Kuspit & Stephen Newton

In his essay on the painting of Stephen Newton, *The Post-Modern Icon*, Donald Kuspit poses a series of questions:

Suppose, as I think, 20th century abstract art has by and large lost its creative depth and become an academic mannerism: an illustration of the idea of spiritual pictorial space rather than its ecstatic substance. Then the question art faces – at least for art eager to serve and "substantiate" the spiritual unconscious – is how to sustain spirituality without its abstract mode of articulation. (1) More simply, how can spirituality be made to seem credible when the abstract art that has been its modern vehicle has become shopworn and outworn, that is, old? (2) If familiarity breeds contempt, as the saying goes, then by becoming all too familiar and respectable – as its institutional success indicates – abstract art seems to deserve a little contempt. For out of avant-garde necessity – the avant-garde compulsion to rebel against whatever has become a tradition, however untraditional it once was – the critical spectator, along with the critical artist, must repudiate an art once it has acquired "bourgeois" credentials. Assimilated by society, abstract art – supposedly the peak modern art has been struggling to climb from the start – suddenly loses its authenticity and difficulty, and becomes, as Max Horkheimer has suggested, no more than entertaining wallpaper. (3)

Call this the question of post-modern spirituality, or, more precisely, of the post-modern possibility of spirituality, that is, the problem of how to embody the spiritual when the abstract means of its revelation developed by modern art no longer seem able to do so. They have become simply another language of art, in which the artist makes many interesting, even intriguing statements – none of which, unfortunately, evoke the spiritual or afford a spiritual experience. Or, to put this another way, abstract art no longer implies spiritual communion, that is, communion with unconscious creativity: depth perception of the creativity that permits people to transcend ordinary superficial

perception, and thus experience the mystery of creativity as
such – grasp its sacredness, by reason of the fact that it is the
source of life, indeed, its last stand and resource in its struggle
with death.

I think Stephen Newton's paintings offer an important, con-
vincing answer to this question: they are post-modern – post-
abstract-icons, that is, painterly images that reconstitute the icon
– the traditional artistic means of embodying spirituality – in
new figurative terms. If, as Newton writes, the icon, in its "*ac-
heiropoietic* function," seems to be a "causal emanation from
the sacred personage whose image it then comes to bear," so
that "the icon is worshipped as the actual sacred body of the
person represented," (4) then the figurative elements in New-
ton's paintings – houses and their interiors and the few pieces
of furniture that exist in their looming emptiness – are the at-
tributes of an invisible spiritual personage, symbols of his sa-
cred body, as it were. But the question is, who is this sacred
personage? How did he become sacred? What does it mean to
be sacred? It has to mean to discover one's own spiritual un-
conscious, more particularly, to make one's own unconscious
creativity manifest in one's life, in defiance of the odds of do-
ing so in a world indifferent to it, and oneself. Traditionally, a
sacred person is someone who has been saved by the grace –
creativity – of God, in whom he has placed his faith. In our
godless world, a sacred person is someone who has been saved
by his own creativity – by having faith in his own spiritual
unconscious. In other words, the sacred person is an "artist" in
principle.

Newton's pictures give us a view of an inhospitable, indeed,
inhuman space, which diminishes whatever is in it. Everything
becomes smaller in it, as it becomes too big to bear. His picto-
rial space it is essentially deserted – the epitome of an emotion-
al desert. Human reciprocity is impossible in it – altogether
extinguished, as though it had never existed. Indeed, the radical
emptiness of the space embodies the impossibility of being
intimate in it. Newton's space has an air of remoteness about it,
conveying feelings of separation and isolation – radical loneli-

ness. Crucified by the surrounding emptiness much as Christ was crucified on Golgotha, Newton conveys the martyrdom – living death – of the unloved, unwished for, abandoned child. Implicitly it must be himself. The space must be his inner space, projected into the picture – given pictorial form.

Newton's paintings are, on one level, flashbacks to childhood feelings of inner solitude – desolate instances of unhappy childhood memories of home life, or rather home death. The child itself is not portrayed – the objective correlative, as it were, of its subjective feeling of lacking a self and not being a person. Indeed, there is an impersonal air to the bleak space, however much this is contradicted by the aggressively personal way it is painted – a tension, dialectically unresolved, which I will explore later. There are in fact no people anywhere in Newton's paintings, no human presence, friendly or unfriendly, in the pseudo-home he pictures – often from the outside, turning it into a kind of toy, and seeing it from a great distance that makes it abstract – only things, sometimes living (flowers), usually dead, and all peculiarly emblematic and thus oddly unreal, or rather uncannily real. The atmosphere is one of stultifying indifference, conveying the emotional indifference with which the child was treated. Newton's pictures are clearly not of a childhood recollected in tranquillity, but in a kind of quiet – at times not so quiet as the manic painterliness suggests – rage.

Clearly, the modern idea that art regresses to a child's vision of reality in order to serve the troubled ego of the adult has reached an ironic climax in Newton's imagery. It is always hard to grasp the emotional reality of one's childhood environment, all the more so because one is supposed to have had a happy childhood – a social fantasy that serves childhood amnesia – but Newton, courageously, shows that it is usually more unhappy than happy, because one's parents were not the most facilitative environment, all the more so because they rarely sponsored one's creativity, having none themselves.

In his book *Art & Ritual: A Painter's Journey* Stephen Newton replies:

I stress again that I am not seeking canonisation and Donald Kuspit's brilliant essay on my painting explains how the idea of sainthood gets conflated with the artist attempting to come to terms with a world often oblivious to individual creative endeavour. It is rather from a psychoanalytical and theoretical ground that I have tried to make sense of such deep conversion experience and to grasp what really occurs during these arcane transformative events.

It might not be self-evident to the casual observer, but in fact every single aspect of a painting's intrinsic formal and material qualities, including painterly gesture, marks and striations within the brushstroke, impasto and textural features and so on, all present analogies and representations of inner psychic events and projections. In the natural order of things and in the way the human psyche evolves, those elements embedded within this formal language of painting which appear to be distinctive, clearly demarcated, to some degree composed and deliberately ordered or refined, come to represent those factors in the mind upholding regulation, conscious organisation and ultimately inner laws and conscience.

By contrast, the elements which fall foul of such formulations, like scratches, drips, random marks, distortions of intention, dislocated line and other complex anomalies, can appear to threaten the rational and law-like directives of composed and ordered factions. Such constituents of facture are altogether 'inarticulate,' inchoate, raw and spontaneous, although they can be intuitively and subliminally monitored and even actively procured by the sensitive painter. It is this inarticulate form, in its radically exorcising and transgressive nature, that carries the emotional charge and vitality giving painterly form expressive power.

In a paper written in 1998 entitled *Guilt in Painting*, I examine inter-reaction between these two types of form within the cruci-

ble of the creative process. Again I describe the two opposing types of form: the formal representations of order and cohesion as basically the product of a deliberate, perceptual engagement and the informal representatives of disorder and dislocation beyond predetermination or control in any normal sense. I argue that an alleviation of guilt and even a potential redemption can be achieved within the dialectic between these two categories:

It is in the dialectical core of the relationship between these two types of form that guilt is determined. The consciously organised formal aspects of deliberate engagement that I have described, are also employed by agencies in the mind which act to ensure that conscious rational order and perception maintain dominance, an objective which in part is biologically adaptive. Psychoanalytic theory might describe such agencies as "repressive," and perhaps as being the residue in the mind of early parental discipline and social controls. In order to assert the supremacy of conscious organisation, they enlist the assistance of guilt feelings. That is to say, feelings of guilt are induced in the mind if the surface cohesive organisation is threatened in any way by the disruptive and transgressive forces of unconscious inarticulate form. Inarticulate form in its own basic characteristics as the language of the archaic unconscious psyche also carries a loading of guilt and anxiety associated with the savage earlier stages of infancy, and embryonic symbolisation.

Now it is possible to enter a central phase in the creative process, where the dialectic between these two different types of form in the painterly structure is mediated or resolved. In this phase those formal elements of definite cohesion, representing conscious deliberate determination and perception, can be painted out, obliterated, dissolved and subsumed within the unconscious painterly matrix. At one and the same time, elements of fragmented inarticulate forms and their compounds with

more definite configurations will be joined and inte-
grated within the whole. Now the removal from the
scene of those representatives of conscious rational or-
der and perception also means that they can no longer
fulfil their function to keep order by arousing guilt and
anxiety often through enlisting feelings of disgust. Si-
multaneously, inarticulate fragmented forms along with
their associated guilt and anxiety are integrated and be-
come an acceptable part of the whole.

In effect, therefore, the repressive psychic forces are
neutralised, their agencies in organised forms are dis-
solved, and guilt is completely vanquished. The painter
can fleetingly experience a feeling of total omnipotence
and unchallenged control of all forms and what they rep-
resent in the mind. In Oscar Wilde's *The Picture of
Dorian Gray*, it is the painted portrait image which takes
upon itself the anxiety and guilt of a dissolute lifestyle,
whilst the subject, as a metaphor for the artist, acquires
an omnipotent, guilt-free lifestyle and the ability to for-
ever resurrect a new psychic self. (5)

I think that this description of what goes on at the core of the
creative process goes some way to explain how the resolution
of the innate dialectic here can lead not only to feelings of om-
nipotence as all forms are integrated, but also to a momentary
trance state as the representations of consciousness are dis-
solved within the matrix. In essence these forms actively repre-
sent our conscious mode of constructing reality. They are repre-
sentations not only of our psychological process of perception,
but also of concept-formation and symbolisation. So as these
forms disappear, so does the very embodiment of all that sym-
bolises a sense of self. It is this progressive neutralisation of
ordered representations that is responsible for the potential
trance 'death' that forms the core of ritual experience and cre-
ates the conditions for a reorientation of psychic structure.

The description is also very apt in respect of the abstract col-
lages. In *Untitled (Grey)* 1983 (reproduced above) traces and
apparently receding after-images of vaguely organised shapes
seem to be dispersing into a grey flux. They are intermingled
with other components of organised and disorganised forms,
elements with distinct shapes perhaps embedded with a multi-
plicity of raw scraps of painted or scratched line or ragged
collaged edges and so forth. The intense manic-oceanic trance
experience that I detailed in respect of this collage was further a
direct result of the conscious confrontation with the 'poly-
phonic diversity' and complexity of the creative process. The
conscious cognitive processes become 'overloaded' in the face
of such diversity and breakdown or become immobilised as the
more all-embracing intuitive and subliminal processes of un-
consciousness are forced to take over.

So consciousness is not only dissolved and negated as its representations are obliterated, but is also simultaneously disabled in the face of an overwhelming complexity beyond its scope. Hence a transitory trance state and *ekstasis* are engaged as consciousness shuts down and the unconscious structure of the mind is reorganised in a *trance-formation*. There is, therefore, a plastic analogy in the death of consciousness within the materiality of the collage, an analogy simultaneously provoking a parallel, reciprocal psychic trance 'death' within the mind.

It can be seen that within this apparently innocuous and unrepresentative space, a whole range of developmental issues can be renegotiated. In the ongoing dialogue with the painterly matrix, all of the original formative reactions that seem to define the inner mind are again engaged. Toleration of frustration and anxiety, the rehearsal of positive and adaptive levels of aggression, guilt, conscience, projective identification: all can be encountered within a scenario free of real threat, but with the real potential to greatly toughen the ego and effect a metamorphosis into a new self.

Such an intense and elementary transformation is made possible because this creative encounter is prior to the development of any representative or figurative imagery, narrative or fully formed symbolism. These factors, of course, represent and embody earlier turmoil, but they are once removed and so to a degree anaesthetised for the accession of consciousness. By its nature, the conscious mind is not equipped to deal with the flux of powerful emotions at the formative dynamic levels. This is why unconscious, or 'inarticulate' form can appear to be so transgressive and radical and pose such a threat to the conscious mind. Such form carries all of the force of the *original* dynamic experiences, often traumatic in nature and all the more powerful because they are original.

To put it another way, powerful emotions capable of overwhelming the stability of consciousness are couched in abstract, indecipherable forms that cannot be reconceived by a conscious

mind unable to cope. Again, this is why the emotional power of artistic form resides in its intrinsic formal language.

When I gave the red monochrome collage the title *Promised Land*, it was done after completion of the work and entirely innocently and instinctively chosen. I recognised intuitively that I had reached a place that I needed to reach for my own survival and well-being. I understood that it was a dimension where all of these developmental issues could again be confronted. The dimension is prior to the acquisition of language or symbolism and beyond representation. This is why the primeval *Promised Land* held out the promise of a radically emotional encounter. It goes beyond the original formulations of psychic organisation and so presents the unique potential for a psychic rebirth and the creation of a new self.

Looking back with hindsight at this painting, I can now detect the duality between the 'death' of consciousness within the materiality of the work and the reciprocal trance, momentary loss of consciousness and consequent rebirth in the actual mind. In its complete obliteration of conventional line, colour, representative shape and organised composition, conscious points of reference are reduced to an absolute minimum. However, within the excoriated terrain of this collage there can be detected the fragmented remnants of limbs and organs which psychoanalytic theory shows to be associated with these primal developmental stages. There is certainly the hint of a vaginal triangle and I would have to say now that the whole aura of the unconscious colouring is inter-uterine. So there is the clear duality and parallel of form and content. *Promised Land* creates the conditions for a psychic rebirth alongside the plastic metaphor of an actual rebirth through the inter-uterine experience of the body of the work.

Notes

From *The Post-Modern Icon: Stephen Newton's Post-Abstract Paintings* by Donald Kuspit, originally published in *Stephen*

Newton: Paintings and Drawings 1997-2000, Ziggurat Books, London, 2000.

1. The issue in part involves convincing the typically "spiritless" and sceptical modern spectator of the reality of the spiritual unconscious. He must be made vividly conscious of its process, so that he has a kind of "conversion" experience of it – an unexpected "peak experience," as it were, of his own unconscious spirituality and creativity. However momentary, this has a lasting effect on him, all the more so because of the novel sense of freshness of being and startling self-knowledge it affords, which remain fixed in his memory as experiential ideals.

2. The feeling that 20th century abstract art has become bankrupt, or, more simply, a stale, flat, and unprofitable enterprise, and that art must move on to the "next step" – all the more so because the fin de siécle and even more dramatically the millennium is at hand, and abstract art has been the dominant if also controversial art of the century – may simply reflect the modern truth that, in Hans Eysenck's words, "artists... inevitably search for novelty". "What has been done once cannot be done again. A given style in art finally collapses, and a new style...arrives because the old style has nothing new to contribute. Artistic production is judged in terms of its 'arousal potential', i.e. in terms of what Berlyne called 'collative properties', such as complexity, surprisingness, incongruity, ambiguity, and variability." Hans Eysenck, *Genius: The Natural History Of Creativity* (Cambridge: Cambridge University Press, 1995), p.159.

At the same time, it may be that if, 'within a given style, arousal potential is produced by what Martindale calls primordial content,' i.e. by what Kris called 'primary process thinking' (pp.159-60), then 20th century abstract art has lost its primordial content and no longer involves primary process thinking. It seems logical that, after a century of mining such content and swimming with the changing tides of primary process, abstract art has become exhausted. Of course, we may also want to hustle it out of the way because, after a century of life, it has

come to seem like ancient history, and thus unconsciously reminds us of death. However, it may not be dead, but rather pausing to regroup its energies – lying fallow to renew its spirituality.

3. As Max Horkheimer writes in *Critique of Instrumental Reason* (New York: Continuum, 1974), p.99. "total abstraction... has become pure wall decoration and is accepted as such, at least by the wealthy who buy it... Abstract pictures are simply one element in a purposive arrangement." Thus, the dimension of the absolute is disappearing from an art that thinks of itself as wholly free... Works of art... buy their future at the expense of their meaning."

4. Stephen Newton, 'The Creative Structure of Psychoanalysis' (1996), *The Spiritual Unconscious: Stephen Newton, Paintings and Drawings 1975-1996* (London: Ziggurat Books, 1996), p.124.

From *Art & Ritual: A Painter's Journey* by Stephen Newton, pp. 67-70, Ziggurat Books International, London & Paris, 2009 (Copyright 2006):

5. Stephen Newton, 'Guilt in Painting', *Art Criticism*, Vol. 13, No. 2, 1998.

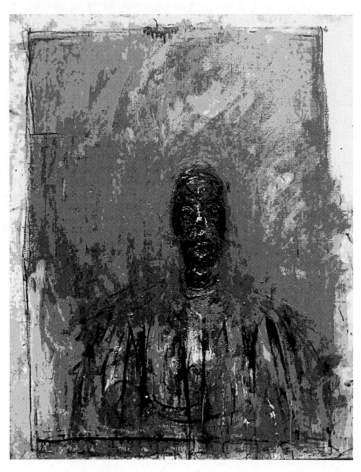

Alberto Giacometti, *Tête Noire*, 1960

CHIASMIC PAINTING: ART & DEATH
Judith Chandler

The method of over-painting has been used by many artists, de Kooning especially (1), who stretched his paints by adding vegetable oils, scraping back and then accumulating layers, re-working images until they had the right 'feel.' Gerhard Richter employed serial obliteration, photographing the process in his 'Red' painting of 1994. Giacometti too drew over and over the figure to find the 'right' line. Merleau-Ponty calls this technique *'chiasmic,'* meaning moving between the visible and the invisible, between pleasure and loss. (2)

If a drawing is abstracted by destroying and decomposing form then when painted, the image is repeatedly obliterated until it becomes something entirely other. My experience is that working through the layers is rather like peeling back the surface, burrowing within until its authenticity is revealed, not unlike how Michelangelo imagined the form inside a block of marble. As a painter, the idea of death and resurfacing often recurs; difficult subjects like crucifixion, suffering and death have long been the source of works of art.

Time spent not painting marks an accumulation of experience, of life and the variety and depth of relations that come with dreams coming true, with failure, disaster, loss, grief, the development of compassion, of anger and of love. What happens is that one begins to weave a bigger picture of how things fit together, distilling the experience until it can be expressed. When this happens, life can be viewed, not from the obsessional problems and niggles of every day, but from the wider perspective of being. Thomas Moore believes that pain, failure, anger, violence and redemption from them are the sources of much wisdom and transformation.

> *...to make the subtle moves that allow the soul to reveal itself...You have to rely on every bit of learning, every scrap of sense, and all kinds of reading, in order to bring intelligence and*

imagination to the work...Intelligence and edu-
cation bring you to the edge, where your mind
and its purposes are empty. (3)

John Dewey referred to the aesthetic state as heightened and intensified experience, which emotionally connects the person to the work. He believed that without emotion, there might be craftsmanship, but not art. (4) Dewey discussed this in *Art as Experience*: that, through the resistance of hardship and sadness, the nature of the self is encountered and brought into consciousness by interacting with the environment. Dewey held that no work of art would ever be produced without overcoming external necessities and incorporating them in an individual vision and expression. He believed this to be a more important factor than the contrast between work and play (Schiller), necessity and spontaneity, or law and freedom because art fuses the experience with the self to produce the essential spontaneous conditions.

Likewise, Anthony Storr (5) believes we are all idealists. Trauma is important to the artist, as is technical skill, in enabling him *"to rise above the merely personal and to relate his personal deprivation to the discontents implicit in being human."* Disappointment happens to all, the need to link the real and the ideal is a productive tension, requiring constantly new solutions. And, although expression does not change the circumstances of the events that shape us, it does free us of the weight *"...which made them painful or wounding, they become transparent or even luminous, and capable of clarifying not only the aspects of the world which resemble them, but the others too."* (6)

Following my mother's death this year, a painting arose out of the relief of finally resolving the distance between us in life, and celebrating the end of her suffering. When I began to use pumpkin yellow (permanent yellow deep, a colour she liked) on the small canvas below there were resonances of memories and associations that began to surface, and I knew what the painting was about. At that point, I could resolve the conflicting emo-

tions arising with paint handling and composition and so forth, the work dictating when it was finished (*Resolution*, 2008 as reproduced below).

In death, coming face-to-face with our own mortality teaches us about life and living. (7) Painting transcends all that we have been through by providing tools to facilitate doing, expressing, feeling alive. Perhaps art also provides a language to express the conception that as beings, we are not unique or isolated, but

that our existence and thought are integrated with other beings, with nature, with the past and the future.

Something of life's experience arises within a painting, a bit of suffering shapes the depth of expression, makes it more universally understood, and therefore aesthetic. Life's experiences cannot be represented except aesthetically, *"because their source is the wounding of beauty (Perfection)."* (8) And painting is not simply surface, or depiction or narrative, it is also something formed from within, an inarticulate cry. The formal and aesthetic sides of painting do not exist in isolation when creating images, both arise naturally, indistinct from one another. Merleau-Ponty believes this is imbedded in the choices of line, colour and texture the artist makes, a choice of vision. Vision is not a mode of thought, it is "precession," (9) a spinning rotation between what is, what is seen, and what one chooses to make seen. It is *"...the means given me for being absent from myself, for being present at the fission of Being from the inside – the fission at whose termination, and not before, I come back into myself."* (10)

Physically working on the aesthetic surface is a way into the process, and, once established, content gives form to the work. There is an extreme complexity and interdependence between the brain and the body. (11) I consider that critical reflection seeking to understand consciousness is a component of not just one part of the body (the mind), but courses throughout and is expressed instinctively by the hands, the face, the feet, and the skills learned and stored therein.

Increasingly, I am aware that what is essential is the creation of images which reside somewhere outside the limits of my conscious mind, that pull together and recollect experiences in an emotionally moving way. *"Painting is research into Being, a quest that never ends."* (12) It initiates transformation, born of joy and emotionality, unhappiness, sadness and frustration. The aesthetic surface is a way into the process, and, once established, content gives form to the work.

Found within the writings of Nietzsche and Heidegger is the notion that there are moments of creativity when past, present and future come together. Painting is one such moment. Paintings are shared, exhibited, and given away, and not simply personal expressions.

For more than 300 years, Descartes' *'I think therefore I am'* led us to believe that the existing world is not visible, that the only light is that of the mind, but a painter cannot believe this. (13) Man is a creature so often unhappily divided that he needs works of imagination to make him whole and offer his deepest consolations.(14) Painting presents the artist with the feeling of wholeness and satisfaction of having met and transcended powerful emotional states.

Notes

1. Arsen Pohribny, *Abstract Painting,* Phaidon, Oxford, 1978, p.94
2. Briony Fer, *On Abstract Art,* Yale University Press, London, 1997, p.152
3. Thomas Moore, *Care of the Soul*, Judy Piakus Ltd., London, 1992, p.10
4. John Dewey, *Art as Experience.* Capricorn Books, New York, 1958, pgs. 281-282
5. Anthony Storr, *The Dynamics of Creation.* Penguin Books, London, 1991, p. 291
6. Maurice Merleau-Ponty, cited in Johnson, G., *The Merleau-Ponty Aesthetics Reader: Philosophy and Painting*, Northwestern University Press, Evanston, 1996, p.101
7. Elizabeth Kubler-Ross, *Life Lessons*, Simon & Shuster, London, 2001 passim
8. Gerhard Richter, *The Daily Practice of Painting*, Thames & Hudson, London, 2005, p.102
9. Maurice Merleau-Ponty, *The Primacy of Perception*, Northwestern University Press, Evanston, 1964, p.188
10. BID, p. 186

11. Danah Zohar, *The Quantum Self*, HarperCollins Publishers, London, 1991, pgs.80- 81
12. Maurice Merleau-Ponty, 1964, p.186
13. IBID
14. Anthony Storr, 1991, p.295-6

Piers Faccini, *Head of Antonin Artaud*, 1991

Andrea Mantegna, *Il Cristo Morto*, 1490

HORIZONTAL AND VERTICAL IMAGES OF DEATH: ANDREA MANTEGNA AND MICHELANGELO DI LODOVICO BUONARROTI SIMONI

Sr Anselma Scollard OSB

My death is certain but the hour is unsure,
Life is so brief and little now have I;
So sweet it is to sense, yet cannot lure
The soul. My spirit prays that I may die...

Oh God, when will that time arrive which he,
Who trusts in you, expects? Hope falls away,
And fatal to the soul is great delay...

Michelangelo, *Sonnet LXIX*

Nearly seventy-five years separate Andrea Mantegna's *Il Cristo Morto* and the *Rodanini Pieta* of Michelangelo. The Mantegna painting's date of execution seems to be something of a matter for conjecture: a span of 15 years exists between the earliest possible date and the last. One thing is unquestioned however; it was created in the latter years of the artist's output. By contrast it is known with certainty that Michelangelo worked on his last Pieta up until six days before his death. It remained unfinished, left in his studio, apparently bequeathed to his servant. The dead body of Christ is the central focus of both the Mantegna and the Michelangelo, but in many other ways the works are completely different: one is a painting, the other a sculpture; one finished, the other unfinished; one dealing with the finality of death, the other described by some as symbolic of the Resurrection.

The two works are located in Milan, a city which never approached the artistic productivity so evident in the Renaissance Florence. Their site-ing is a fact of history, but the location is also important in so far as it affects how the works are presented and how the viewer sees them. I hesitate in using the word *viewer*, because the physical situation of neither of these works is comparable to that of a large metropolitan museum. One does

not go from gallery to gallery, from painting to painting as for example in the Louvre or the Uffizzi. One goes rather almost in the spirit of a pilgrimage, a lonely quiet encounter, which would be impossible in a large crowded museum gallery. The two works have an air of *privacy* about them, given in part by their surroundings. They are to be seen, but are not *on display* so to speak. In one sense they have no public *persona* as do the first Pieta of Michelangelo or Mantegna's great work for the *Camera degli Sposi* at Mantua.

Both works are profoundly religious in character. By this I do not mean that they cannot be appreciated on a purely artistic plane, but rather to do so would be to fail to grasp the whole point of their existence. They speak about death, which unless it is understood as being of religious significance, is totally misunderstood. I realize these words may seem to some provocative or to others demonstrative of a narrow point of view, but what I mean is this: if death is *only* the final end of everything that pertains to the individual, merely the stopping point of so many *one offs* or individuals, then it is of no significance; there is nothing to be feared or hoped for, precisely because there is nothing beyond. (Unless ironically one fears extinction.) But if death, and its treatment by art, concerns the conclusion of earthly life (its closure and completion) then the eternal worth of that life and its *depiction* by art must have a religious quality about it — i.e. it must pertain to the eternal — therefore divine, and not the mere termination of temporal existence as we know it. Clearly this becomes even truer when the subject matter of the work of art is the dead Christ, even though one could argue that the vast number of art works of this period were concerned with a specifically religious subject matter. What I hope to reflect on in this paper is how the approach of death occasioned a radical shift in the formal expression the artists took in depicting it.

Some historical background is of importance here: both the works we are referring to were found in the respective artist's studios at the time of their death. They seem not to have been commissioned works. Concerning Michelangelo's, this is al-

most certainly true. It was bequeathed to his servant Antonio del Francese, a fact which seems to express further the personal character of the work. Mantegna's painting and Michelangelo's sculpture, being latter works of the artist's lives, figure among several others which also deal with death: two Pietas (paintings) and the martyrdom of St. Sebastian in the case of Mantegna, and several crucifixion drawings in the case of Michelangelo. The *Pieta of the Stone Cutters* by Mantegna is roughly of the same period as his *Il Cristo Morto* and is interesting in that, although it depicts a Madonna and Child, the Christchild instead of being portrayed in the customary sitting position is in a reclining position as for a Pieta. The thought of death in this painting is further emphasized by the stony background reminiscent of scenes of Calvary. Mantegna's martyrdom of St. Sebastian, is also roughly of the same period, i.e. 1490, and bears the inscription: *Nihil nisi divinum stabile est. Coetera fumus.* ('Nothing except the divine is stable. The rest is smoke.') St. Sebastian stands framed in stone within a black background, of what can only have the semblance of a tomb. However vertical the depiction, the saint remains encased in a sepulchre, the only signs of life being the expression on the saint's face and his foot extending beyond the frame of the picture. Like the Brera *Il Cristo Morto* it too was found in the artist's studio at the time of his death and reflects the same theme.

The Brera *Dead Christ*, although not entirely surrounded by a frame of stone as is the *St. Sebastian*, lies on a mortuary plinth. Its lighting has been described as having an air of 'eerie twilight.' Yet it is the body itself which diffuses the light in what is a strikingly limited pictorial space. From whatever vantage point one stands in this relatively small room, the figure of Christ commands our attention, not by following us, as some have suggested, but by drawing our eyes to the body placed on the wall. However, what remains the most impressive feature of the painting is its utterly bleak statement of death — death framed, motionless, final, incontestable. Yet in spite of this, an atmosphere of peace and stillness pervades. The grieving figures of the Virgin and St. John almost seem to disturb this peace by their *living* presence. (They are thought by some to be

an addition and not by Mantegna himself.) The figure of Christ is of another world, yet so defiantly present in this one. Such is the reality of the corpse: immoveable, but somehow absent. The entire plane of the picture is taken up by the body of the dead Christ. The mourners squeezed in to the left of the figure (from the viewer's perspective) only emphasize the magnitude of this death, where the mourners seem to be only of secondary importance. I can think of no other portrait of death in the history of art which portrays death so authentically. The word *authentic* is important here, as signifying the entire *feel* of death, rather than a merely accurate description of it. Here there is no expectation of the Resurrection. This is death alone, when the soul has gone, but — and this is important — it remains the death of Christ in his humanity.

Michelangelo, *Rodanini Pieta*, 1564

Michelangelo's *Pieta Rodanini* presents us with another view of death. The last work of an extraordinarily prolific career, it is Michelangelo's final statement. The *Pieta Rodanini* is often interpreted in a way similar to all the other Pietas created by the artist, including the *Florentine Pieta* with which it is sometimes linked. The two works are actually quite different. The *Florentine Pieta* was referred to both by Condivi and Vasari (biographers of Michelangelo) as a 'deposition' — a taking down of the dead body of Christ from the cross. The *Rodanini Pieta*, to which Condivi makes no reference (an un-commissioned work, begun in solitude and the artist's last expression), was perhaps begun as an entombment, as indicated by a group of studies, where Christ is being carried to the tomb by Mary and Joseph of Arimathea. But what was begun as an 'entombment' sculpture of three figures became in the end a standing Pieta of two fused figures: the dead Christ and his Mother. As a whole it is unfinished but with finished parts: an arm that is separated from the whole and the completed legs of Christ, and hence it is a juxtaposition of finished and unfinished. Yet in spite of this there is a perfect balance of unity and movement. Spiritually the dominant theme is one of unity and support.

The Rodanini sculpture as a Pieta depicts the dead Christ and his Mother, but because it is a *pieta* it has always been assumed that the Virgin Mother would support the dead body of her Son. But visually, because the *Pieta Rodanini* has been *reworked* on a vertical plane, and because the Mother stands behind her Son, the appearance is rather that of Christ supporting his Mother. In the Son's death their roles have been reversed. Christ in his death has become the living force supporting the dead weight of his grieving Mother. The frontal position of the figure of Christ in relation to his Mother, who stands behind her Son, perched as it were on his shoulders, gives the impression that he now has become the cross and she the victim. It is precisely in this reversal of roles that Michelangelo has created one of the most powerful images of redemption in the history of art. In dying Christ gives life. In taking humanity upon himself quite literally in this image where he carries his Mother upon his shoulders, he bears all of humanity as he does his Mother. This posture of

bearing, this gesture of carrying, is reminiscent of the earliest artistic Christian images of the Good Shepherd found in the Roman catacombs.

With the *Pieta Rodanini*, what is described as a *pieta* is as much an image of Redemption and Resurrection. Through the upward thrust of the figures it does in fact resemble more closely the numerous drawings of the Resurrection made by Michelangelo than it does any of the Pieta executed by him. In what can only be described as a profoundly Christian image, death gives birth to life. Unlike the Mantegna, whose arresting imagery is dependent on the foreshortened figure of the dead Christ lying in a completely prone position, and so forsaking the standard pictorial plane, it has become an image embedded in the wall rather than on the wall. By contrast in the *Rodanini Pieta*, Michelangelo has radically altered the normal configuration of a seated and reclining figure of Mother and Son to present a totally vertical composition, where the Mother no longer supports the body of her Son, but is rather supported by him. It is not a death which is being mourned, but a life which is being engendered, in this the artist's final work. It is a movement towards eternity, an unfinished gesture moving towards another place and a future time. And yet it is a finished work resolved in peace and rest.

Both Mantegna's *Il Cristo Morto* and Michelangelo's *Pieta Rodanini* were created at the time of life when death is no longer distant, and in the case of Michelangelo, when it was actually imminent. Is it this fact which is responsible for the radical change in their respective depictions of death and the extraordinary originality with which they expressed it? Is it their own death which they see in the image of the dead Christ, so that it is no longer merely the portrayal of an historical and biblical event commissioned for a sacred building or executed as the result of a papal command, but their very own death which they confront in the death of Christ? The fact that neither the painting nor the sculpture were commissioned and that they were found amongst the artists' last belongings are indications of their personal character. Rooted in the past, yet expressing

something new and unknown, they denote the proximity of death, which has given birth to these final artistic testimonies.

How then do Mantegna and Michelangelo look at death? Mantegna has created a quasi 3-dimensional painting, totally horizontal in aspect, and yet it remains a two dimensional painting affixed to a wall. Death has been literally *walled in*, an emphatic termination of life. The dull light, the utter stillness seems without hope. There is no life. (It is interesting that the very last paintings Mantegna did were monochromes of classic themes, stone-like friezes. They have been described as 'sacred marbles'.) The *Brera Christ* presents death in its finality. Michelangelo's *Pieta Rodanini* on the other hand is totally vertical in movement, in contrast to the customarily seated pieta of the past. It is an unfinished piece, which fact allows so to speak, a *visual continuation*. It is a figure of death in its movement towards life. The thrust of this last of Michelangelo's Pietas is the same as to be found in his drawings of the Resurrection, originally intended for the Sistine Chapel. Yet it remains a figure of death, not the death of finality expressed in the Mantegna *Il Cristo Morto*, but a death which will become resurrection and life, a death which is redemption, human and divine.

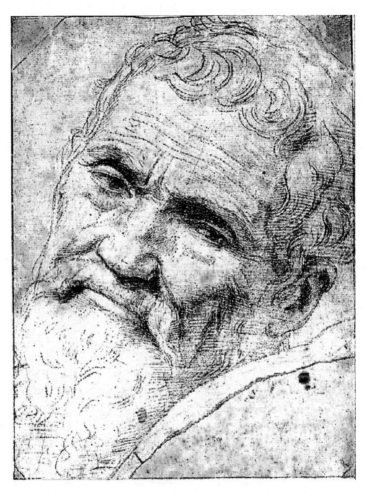

Michelangelo, 1550

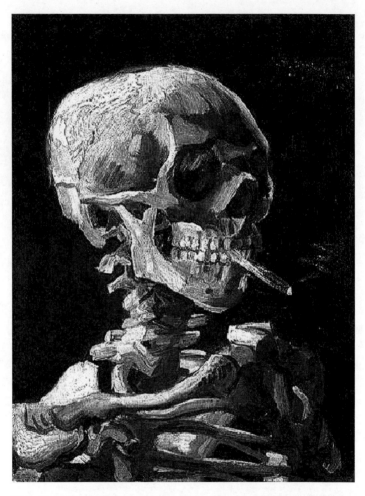

Vincent van Gogh, *Skull of a Man Smoking a Cigarette*, 1885-1886

ARMAGEDDON: AN ETERNITY
Mike von Joel

We say that the hour of death cannot be forecast, but when we say this we imagine that hour as placed in an obscure and distant future. It never occurs to us that it has any connection with the day already begun or that death could arrive this same afternoon, this afternoon which is so certain and which has every hour filled in advance.

— Marcel Proust

ART is a little word to mean so much. It always described big ideas, although these great concepts were invariably contained within coherent parameters. Art once meant drawing, painting, sculpture and – when carried out by artists themselves – print-making. Even the celebrated avant-garde movements adhered to the basic principles of Art practice, despite trying to destroy its fabric from within.

But that was then and this is now. Today Art is a little word that cannot begin to encompass the chaos of activity that claims a kinship. Contemporary Art is multifaceted and a cacophony of 'artists' perform their parts; but let us not dilute ourselves with the wider world. We shall focus on the disappearing art of painting and the arrogance of the painters – and the obsession that curses their lives.

In thinking about the ritual of painting one immediately confronts a seductive security blanket of ancestral delusions. In reality, the acolyte painter is not joining an historic brotherhood with fraternal ties to Leonardo, Rembrandt or Titian (you can insert your own genius here). The only thing all painters really have in common is that first mark on a blank surface and the unleashing of unknown possibilities. Painters in the 21st century can have no real understanding of the life of an artist in the 17th or at any other time in the past. But of course, human nature being what it is, the painter today convinces himself that had he been sipping coffee at the Hotel Carrel in Arles in 1888, he would immediately have bonded with Vincent van Gogh sat

sulking at the next table. Would have instantly recognised Vincent's extraordinary talent. This is the stuff of all painters' selfish dreams.

Coincidentally, Van Gogh is an interesting example of the true painter who took time to find his métier. In a career that spanned a mere ten years, he burnt out trying to make up for time wasted searching for a language with which to express himself. Even today, the Victorian fable of the tortured artist starving in a garret (*La Bohème, Trilby,* Chatterton etc.) is omnipresent – and van Gogh is naturally regarded as a case in point. But van Gogh did suffer the curse of all committed artists: a profound understanding that available time is limited by impending death.

The true painter, he that perseveres against all disaster, even the greatest disaster to befall an artist – commercial success – is a victim of that insidious enemy of all creative imaginations: mortality. The general knowledge of approaching death in the creative mind is superseded by an inner, and most vivid, understanding of the actual nature of personal extinction. This, combined with the artists' innate sense of the oppressive immensity of time itself, can and does lead to a paralyzing sense of futility.

Where will even the greatest and revered works of Art be in 1000 – or 10,000 – years from now? What are the points of reference in the human mind? For the artist it would be axiomatic. A term of 1000 years would bring to mind the magnificence of mediaeval art, cathedral architecture, the great feats of stone carving and manipulation of precious metals. A period of 4000 years... surely the Egypt of Tutankhamun and elaborate wall painting. Even an intellectual leap to a 32,000-year span has a frame of reference in the cave paintings at Chauvet, in the Ardèche region of France. (1) These are, in fact, the earliest examples of painting known, although countless examples of Ice Age rock art must have disappeared due to erosion. For the painter there is a comfort in contemplating these 'works,' created for whatever reason, that are still readable today in a narra-

tive sense: horses, reindeer, cattle; plus the more unusual depiction of predators (lions, hyenas, owls, panthers etc.).

The Chauvet Cave (discovered in 1994) also has the celebrated silhouettes made by spitting pigment over splayed human hands pressed to the walls, as well as the Ice Age child's footprints on the cave floor. Meditating on the pre-historic draughtsmen carefully preparing the cave wall surface (another unusual feature at Chauvet) before creating depictions of the outside world and their own obsessions (hunting, food supply etc.) has obvious consolations for the modern painter with a sense of metaphysics. But the genuine creative mind cannot stop at the extreme boundaries of our current civilization, for it has a terrible sense of the enormity of the bigger picture.

The planet Earth is more or less 4.5 billion years old. The human race has cleverly corroborated this by going to the Moon and bringing back rock samples for analysis, which dates the lunar age at some 4.4 to 4.5 billion years. And there have been some cataclysmic changes to the surface and conditions on Earth throughout this time. Whilst a widely supported, albeit complex, theory claims that the Earth was totally sheathed in ice (Snowball Earth) some 600-700 million years ago, it is generally agreed that the last Ice Age (Glacial Period) ended a mere 10,000 years ago with North America and Europe previously submerged beneath glaciers some 2 kilometers thick – and the deep ocean cooled to near freezing point. Surprisingly, the last geological ice age ended around 1850! The 'Little Ice Age' (LIA) while not a true ice age, extended approximately from the 16th century to the mid 19th century, causing regular chaos amongst agricultural societies across Europe at its extremes and spawned a whole genre of Dutch painting.

Meanwhile, recent geological drilling in the Arctic Sea has uncovered evidence that the waters were sub-tropical in nature some 55 million years before present day (Bp) with temperatures at 20C, rather than the current day average of minus 1.5C.

One great source of fossil evidence, the Burgess Shale (2) high in the Canadian Rockies, was once on a seabed. The 505 million year old fossil remains there illustrate a galaxy of long gone, weird beings, which bare no resemblance to any species living today outside the imaginings of Hollywood animators. The anatomically modern human race, descended from upright walking apes, appeared a mere 200,000 years ago.

In the history of planet Earth there have been *five* major extinctions that annihilated the extant dominant life forms, which geologists call, colloquially, the *Big Five*. (3) And in fact, over 99% of all species that ever lived are now extinct.

The dinosaurs appeared around 230 million years Bp with birds developing from one dinosaur strain about 150 million Bp. (4) The most recent extinction – the Cretaceous-Tertiary event (5) – occurred 65 million years Bp and is the most widely remembered for wiping out the dinosaur groups. It was an uneven event. Roughly 75% of all species became extinct though some groups of organisms were relatively unaffected. But extinction does not happen in an afternoon. In the case of the dinosaur genera, which inhabited Earth for over 165 million years, species came and went. The Stegosaurus, so beloved by children, had actually been extinct for 100 million years before Tyrannosaurus Rex appeared – as distant from T-Rex and we ourselves are from the dinosaur era.

The most severe cataclysm to hit the Earth was the Permian-Triassic transition (the P/Tr or Permian-Triassic extinction event). It killed 53% of marine families, 84% of marine genera, about 96% of all marine species and an estimated 70% of land species (including plants, insects, and vertebrate animals). 57% of all families and 83% of all genera were obliterated.

Whatever the nature of Earth and the current negative impact on its climate caused by the stupidities of mankind, the end of all life is assured with the death of the Sun – and this is a quantifiable event.

At the Sun's centre, where the gravitational crush is most extreme, Hydrogen nuclei are repeatedly fused to form Helium. Energy, given up in these fusion reactions, flows outward toward the surface heating the outer layers in the process and puffing the star up to counteract the inward force of gravity. About five billion years from now, all the Hydrogen at the centre of the Sun will all be converted to Helium and the Sun begins to die. It will expand to swallow up all the inner planets including, possibly, the Earth. But by then the Earth has already been toasted to destruction. The solar system will become a black, cold mass of nothing.

However, before this terminal scenario, things could get a lot worse on Earth. The Sun is getting hotter all the time and the temperature on Earth is gradually rising. A point will be reached when evaporation levels are so great that the stratosphere itself will become wet and this will let the Sun breakdown the water molecules and allow the Hydrogen atoms to escape. No water recycle equals no life on Earth.

For the man in the street, Death is but a rumour. Where a new millennium (not even a blip in the great scheme of Deep Time) is a cause for crazed celebrations. For a creative mind, and one focussed on the ritualistic, quasi-religious act of painting, Death is a dreadful construct. It whispers on the futility of all endeavours, the meaningless of aesthetic concerns, the transitory nature of any personal sacrifice. For the painter's art to achieve greatness it must perforce breakthrough this temporal paralysis and commune with that indefinable universal quintessence. The mind must overcome and conquer the oppression of mortality.

What is life? It is the flash of a firefly in the night. It is the breath of a buffalo in the wintertime. It is the little shadow which runs across the grass and loses itself in the sunset.

> – Deathbed words of Crowfoot
> (Native American, Blackfoot Tribe)

The same might be said of all Art.

NOTES

1. On Sunday, December 18, 1994, cave enthusiasts Jean-Marie Chauvet and his two friends, Éliette Brunel and Christian Hillaire accidentally found an obscure shaft. They gathered up essential tools, returned, and went on to discover a vast chamber with a network of enclaves and galleries. On the way back out, Éliette saw an amazing sight in the beam of her lamp: a small mammoth drawn with red ochre on a rocky spur hanging from the ceiling. They began searching all of the walls with great attention and discovered hundreds of paintings and engravings.

2. Discovered by Charles Walcott in 1909, the Burgess Shale Formation is famous for the exceptional preservation of the fossils in which the soft parts are preserved. 505 million years Bp (Middle Cambrian) in age.

3. The classical "Big Five" mass extinctions identified by Jack Sepkoski and David M. Raup in their 1982 paper are widely agreed upon as some of the most significant: End Ordovician, Late Devonian, End Permian, End Triassic, and End Cretaceous.

4. Dinosaur fossils have been known since at least 1818. The term (*deinos* means terrifying; *sauros* means lizard) was coined by the English anatomist, Sir Richard Owen, in 1842. The only three large dinosaurs known at that time were Megalosaurus, Iguanodon, and Hylaeosaurus.

5. The Cretaceous-Paleogene transition (the K/T or Cretaceous–Tertiary extinction event).

Mark Luscombe-Whyte, *Night of the Dead*, Mexico 2001

DISEMBODIMENT AND FRACTURE
Marcus Reichert

Daffodils, paint me cut daffodils
reclining in a summer hat,
said the collector without irony,
tawny port colouring his mouth;
the kind of hat that might adorn
the head of a beautiful woman,
a gatherer of ephemera and dreams
whispering to herself, fear not me.

If I were to buy every painting you've painted,
what would I have to pay;
if I were to burn every painting you've painted,
how big a fire would it make?

The world turns on the pivoting of a coin,
and that coin is essentially without substance,
so says the painter, still lying to himself,
his hand languishing at the bottom of a well.
Munch had vanished from his mirror,
as had Beckmann, and Freida Kahlo;
only their teeth survived the winter,
hidden like harbour lights within a fog.

If I were to buy every painting you've painted,
what would I have to pay;
if I were to burn every painting you've painted,
how big a fire would it make?

Now, when you look at one of my paintings,
he said, nerve quivering round his left eye,
you are staring down the barrel of a loaded gun.
Beautiful, is it not, what with the face of a goat
looking eerily like a newsreader known to many?
Very soon I will be what they call a *talking head*—
a head without a body, surely without a mind,
an epitome of nonsensical elaboration, no more.

If I were to buy every painting you've painted,
what would I have to pay;
if I were to burn every painting you've painted,
how big a fire would it make?

<u>TWO</u>

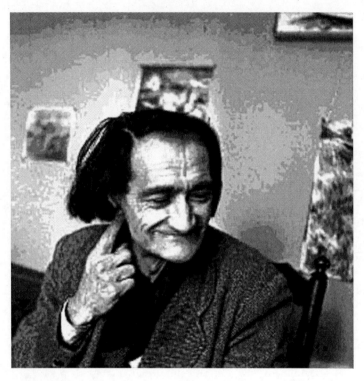

Georges Pastier, *Antonin Artaud*, 1947

ART AND THE WRITING OF ANTONIN ARTAUD'S DEATH
Stephen Barber

On the night of 3-4 March 1948, the French writer and artist
Antonin Artaud died in Ivry-sur-Seine; his final words, from
that night, are inscribed in the last of the 406 notebooks he had
used as his constant creative medium for the preceding years.

Artaud's final notebooks have an exact duration: from the
fixed-point of his arrival in Paris on 26 May 1946, after his
release from the asylum of Rodez, until that of his death in the
early hours of 4 March 1948. Simultaneously, their process is
momentary, and infinite. But a last notebook exists, and last
words are inscribed on the last page Artaud used: a fragment on
page eleven of the 406th notebook, leaving blank the fac-
ing page, and all of the remaining pages, each quadrilaterally
divided, and red-margined. Those words, from the night of 3-4
March, appear almost incidental, ending Artaud's work on the
notebooks as though a great deal more still had to be done, and
intimating, too, that those last words recapitulate an obsessively
repeated preoccupation (already multiply repeated, and requir-
ing yet more repetition, in the future, in order for its impact to
be felt), in the form of an accusation of corporeal assault in-
flicted upon Artaud, who writes, in extremity: 'the same indi-
vidual/returns, then, each/morning (it's another)/to accomplish
his/revolting, criminal/and murderous, sinister/task which is
to/maintain/a state of *bewitchment* in/me/and to continue
to/render me/an eternally/bewitched man/etc etc'. The text (the
last page has no image, although previous pages in the same
notebook do have pencil drawings, of human forms and torture
implements) gives out in perpetually-extended anger, but is bar-
riered by the subsequent pages' void space. On the previous
page of that notebook, another fragment had possessed more of
a tone of culmination, even in its surrendering of a finally-lost
corporeal conflict, as though that previous fragment would have
made a more apposite final statement, of Artaud's terminal fury
against religion as embodying all of the death-dealing social
manifestations he reviled: 'And they've made me fall over the
edge/into death/there, where I'm ceaselessly eating/cock/anus/

and caca/at all of my meals/all those of THE CROSS.' That
earlier fragment, in the last notebook, seals a process, as a final
accusation. But Artaud went on, a few words longer, and the
last words are those that leave the page torn open.

Antonin Artaud, *Page from Notebook*, March 1947

Last words are always isolated, poised at the very end of lan-
guage and image, and in danger, ready to topple, in a parallel
way to that in which Artaud evokes his own body's induced

fall, into death; too urgent to convey themselves fully, those words rely on the condensed force of their own status as fragments, in order to mark themselves upon a space. Many last words are spoken into aural space, such as those of Marcel Proust, who, like Artaud, perceived a figure who was ushering him into death: a hallucinated woman in black, whose presence Proust announced to those around his deathbed on 18 November 1922. Artaud died alone (according to those who found him, frozen in a physical posture that carries the same aura of sudden interruption as his last written fragment: seated on the edge of his bed, in his pavilion, with a shoe in his hand); his 'last-recorded' words are therefore not vocal, but embedded in paper. Once those words have been inscribed – the 'etc etc' of Artaud's final pencil-strokes – an all-consuming, terminal fragmentation appears to seize the future of language and image, and all time has to be propelled backwards, in order for the hard-won sensations of life, in the gestures of text and drawing, to be resuscitated. But the last words also possess an element of release, even as they announce the approach of a sinister assassin, since they are now finally irreplicable, no longer have to infinitely repeat themselves, and become liberated, along with Artaud's body, from the threat of representation, whose power to annul his work he had contested, throughout that work, from its first words.

Artaud's notebooks are the irreducible element of his anatomical work, which reached its most intensive form in the months immediately preceding his death: those notebooks maintain their integral force, and sustain their gestural impact, in whatever time and space they are located. Their intricate history of invisibility and visibility (concealed from sight for decades, and instilled with an acute resistance and an exacting set of ocular demands in their rapport with their spectator) provides them with the aura of an unprecedented apparition: an aura only exacerbated by their textual and visual preoccupation with materializing and projecting an anatomical form that is to be the phenomenal outcome of an impossible transformational process. Their bearing of the traces of combat also sharpens that irreducible form: Artaud's notebooks emanate their status as the

culmination of sustained acts of anatomical wounding and inflicted torture (Artaud's near-decade of asylum-incarceration constitutes a vast archive of incidents of prolonged maltreatment, deprivation and assault) – acts incessantly enumerated and incanted by Artaud in his notebooks – as well as constituting the arena for the multiple combats which Artaud himself instigates: the combat against representation and its complicit enemy-cabal, that between image and text, that between the essential elements of the body and the extraneous or treacherous elements of the body, and that between life and death, in which Artaud always intentionally positions himself, in space and time, on the imminently-collapsing perimeter separating life and death: as he writes in a notebook a few months earlier, a 'night of the meeting between the living and the dead at a particular position on a plateau of the Carpathian mountains.'

The unique physical form of Artaud's notebooks, too, refuses reduction, and cannot be adapted, amended or assimilated. The notebooks bear, as an essential component, their multiple gestural scarifications, abrasures and incisions, which amass at the instants in Artaud's work when his fury against representation bursts, or at the points when the confrontation between image and text becomes most vitally at stake – evident, for example, in the eleven profound incisions that have been inflicted with violence into the closed back-cover of the notebook that contains Artaud's text of 31 January 1948 on the conflict between image and language, *50 Drawings to assassinate magic*, and which traverse every page, before finally exiting through the perforated front-cover of that notebook – as though the projection of such moments demands a simultaneous act of gestural erasure. Artaud's notebooks demonstrate evidence of the traces and memory of the human body at the exact points where it is in most danger of vanishing, of being engulfed; the anatomical transformation and social irreducibility of the human body constituted Artaud's driving obsession in those notebooks, which assemble and sustain corporeal presence. Artaud makes that corporeal presence into one that is essentially contrary – fragmented, damaged, composed of irreconcilable elements – in order to sabotage all attempts to defuse it. Corporeal presence,

in Artaud's notebooks, is immediate and seized in the contemporary instant, but it also temporally expansive, infinite, potentially paradisiacal; that presence is formed from dense, organ-excised carapace, but it is also multi-dimensionally explosive, and spatially insurgent.

Artaud, above all artists or writers, is prepared to face down contradiction, and to make from it an essential working material; only Jean Genet wielded contradiction with a parallel audacity. The form of the notebooks themselves constitutes an astonishing, brazen contradiction: with a total awareness of the impossibility of his project and of the disparity between his medium and his declared intention, Artaud aims, out of the wretched material of those 406 school-children's exercise-books, both to create an entirely new anatomical form for the human species, and also to decimate all social power, all religions, all medicine and psychiatry, and all representational strategies. Contradiction is seized by a transformative will that relentlessly asserts and gesturally intensifies itself, in order to overhaul perception to such a point that what is contrary becomes both extreme and also habitual. The greatest contradiction of all is that which meshes Artaud's notebooks and his own body, in its imminent confrontation with death. The notebooks have, as a prefigured, inbuilt component of their form, the capacity to supplant Artaud's body at his moment of death, so that they survive into the contemporary instant as the residue of that body. But at the same time, by engulfing and holding Artaud's body, the notebooks also allow it to resurge at their own point of expiration and extinguishment (at the moment when Artaud has inscribed his last words into them, and the notebooks abruptly lapse, and fall silent), so that Artaud's body, at the exact moment of his death and of the notebooks' ending, both disappears into his notebooks and also bursts out from them, into another time and space, into another form.

Artaud's body, in death, permanently endures multiple archiving processes: not only the future digitization process of his notebooks and the concurrent future digitization of his body that necessarily accompanies that process, but also the imposed

archiving of the fragments of his body – beyond death, beyond
the textual and the visual, beyond the representational and the
projected, beyond the digital and the corporeal. Twenty-seven
years after his burial at the Ivry-sur-Seine municipal cemetery,
located close to the convalescence-clinic pavilion where he
died, Artaud's body was moved to Marseilles, and then re-
interred, on 18 April 1975, in the Artaud family tomb, at the St
Pierre cemetery, after the skeletal remnants of his excavated
body had been subjected to the then-current technology in
French funeral-industry practice known as 'reduction,' by
which the bones were part-incinerated and then mechanically
compressed into tiny shards, producing a detritus of a suitable
size to be poured into a small box, in order to facilitate the
transportation of that box from Ivry-sur-Seine to Marseilles. In
the process of 'reduction', as though in an additional mortifica-
tion, the body's integral configuration has been irreparably lost
(the body is rendered into a doubly-dead status, following the
forcible entry into a limbo of sexual humiliation – 'death/there,
where I'm ceaselessly eating/cock/anus/and caca' – which Ar-
taud associated with his original death, of 4 March 1948). But
at the same time, that disintegrated body of scorched and pul-
verized remnants is contrarily mutated into a new form: recon-
figured as a dense material which strangely accords with Ar-
taud's incessant pronouncements, in his final notebooks, about
the form of his imminently to-be-transformed anatomy: a limit-
less, unidentifiable, non-representational material, located out-
side perception, finally unseizable, uniquely constituted from
fragments.

No other outcome could exist for Artaud's body. It must always
transform itself, mutating into endless corporeal distillations
and unprecedented manifestations.

This text is extracted from Stephen Barber's *Artaud: Terminal
Curses: The Notebooks* published by Solar Books, London in
2008

Maison de Santé d'Ivry, Ivry-sur-Seine, 1977

LAST COMMENT
Dom Gabrielli

The Sacrifice is done. At the end of transcendence, at the end of the possibility of better worlds? Why? What sacrifice? For the work! As a good writer said: the body becoming book, or becoming painting, it's the same thing. Leaving the biological body for something different which is definitively non-biological. That's what they can't understand at all. A question of sensations. And our way of leaving biology is our particular style, if we're good enough to have one. The will is a stain left on the page by our passing bodies. The poet's honest food is tears. He senses the tug of something eternal linked to the music of another time. An image can conjure up this temporality. A good writer must live there. I am not what you see. My fingers write burnt by the third degree.

Il Professore died this morning. Of all folk I know and knew, he was probably the one who most helped me down this way of words. He took the jump. His suffering too great, he decided it was time for death to take him. He killed himself. He decided to stop eating. He had just enough strength to pull his wheelchair to the window. The wind and all his words and all his ideas tumbling to the ground. My *Professore*'s eyes closed on this life with mine regurgitating their centuries of grief. You suffered the physical consequences of bad luck. And now my eyes are stinging in retreat. There is no point speaking to me. My grief cannot be heard. My eyes communicate with dark soils. I plunge my hands down and dig at the crust. I roll about and clutch my ankles. I lie on my back and cross my legs. I outstretch my arms and press the palms up. Just as they carry you away for good now. Just as they banish your handsome face forever, closed in a wooden box. As if your memory could find a box big enough.

And now they have dug a grave for you, a cold hole in the mud. And they put a stone cave above your neck. Just like the others. Just like the others that got carried away too. The eighteen year old villager hit by a car, the mechanic with cancer, the 93 year

old granny. Their bodies lined up under the earth, waiting for impossible affection. Just like the others, you lie in your best suit and tie. Your sun tanned face smiling at the closed vents of blackness. And whenever the passion plays, I shall seek out a landscape for my eyes to sit and weep and think of you. Why don't they feel this passion? How can they laugh and mock so easily? It is the collusive mob which you depicted so well, their sinister weakness and their eyelashes clogged up in the blood they sheepishly spill. I'll sit at the memorial and sing the optimism of eternal life which you had obtained long before you died. I can feel your cold stony hand closed around mine for-ever.

How do you expect me now to believe in this body, this time, this space? When we cannot tolerate being pinned down to any single spot? We are everywhere already as we come. Just as we move through the folds of memory, as fluid timeless bodies. I leave utopia. Everything I say is practical and proven by fact. I am an empiricist, a rogue to the State. Yet, we are talking of the Spirit now. What would become of us? What of our worldly memories? Of our minds? And this faith in another life? An afterlife? St. Augustin imagined himself in the company of angels, marvelling at images of a perfectly peaceful bliss. St Francis of Assissi had the certainty of an afterlife. Paradise was a just accomplishment for those who had followed the Christian way. What gave them such faith? How could they be so sure? What disturbing meditations lay in ambush for those who could not allow themselves such blind faith? What sounds, what words formed of sounds scratched across the blank tambourine of this notebook can render our intellectual turmoil as I rumi-nate upon such questions? I have surrendered the body.

I felt *il professore*'s spirit invade my mind and I suddenly real-ised how close he still was to me. I imagined his essence no longer knew the slightest boundary and could alight in all those who thought strongly of him. Thus our love for him could live and claim a long life. And simultaneously, I lamented that if no one thought of him, supposing that were so, then his spiritual existence would become ephemeral if not extinct and his newly

found ubiquity would not be of the slightest use to him. In this sense, an afterlife would still be linked to this earthly existence. Indeed, he would be condemned to a vigil before his successors' memories. I imagined the afterlife was a facet of memory. I computed that if writing was the greatest exploration of memory known to man and that writing was nigh an extinct practise then humanity would soon lose any rational link to the afterlife, leaving only superstition and magic in its place, and that death as reflexion would soon die for lack of thought, and writing would follow rapidly behind, leaving spontaneous chatter and sounds to placate the anxiety of the world become mass. Here I am again, crying. The world dies, you die, I die. We are dead. Serve me a drink. I can still drink: red ruby wine. Deep black spices from the Mediterranean. Poor olive oil from my groves. Feel my throat sting. Chew on the wild rocket, sun dried tomatoes. Cling to my loved ones and write poems for nobody.

Henry Miller and Lawrence Durrell, 1962

EXISTENCE: EXCERPTS FROM A NOTEBOOK
Marcus Reichert

1.

The river that flows through Sommières brings nature with it. The Vidourle also brings with it the fluid of humanity. There is something in the French sensibility that positions nature, to its resplendent advantage, at the epicentre of its vitality. The internal dialogue – a philosophical state of mind – weaves its way unobtrusively between buildings and automobiles. We find ourselves marvellously relaxed while at the same time acutely receptive to everything around us. Gazing from the terrace of a café in Sommières down along the river, we find everything precariously in its place. The egret stands for hours in open view on the precipice of the dam breast fearing no one and seemingly wanting for nothing. The ducks carry on circulating in the water as if each day were market-day. The river fastens us to the sun, its grandeur content to assume an ambient role, and to ourselves, as we feel its silent swarming pulse within us.

I first encountered Lawrence Durrell in Sommières, his final retreat, in the form of a black and white postcard. Durrell and another man were captured in the street, each bringing home the bread. He appeared, lost in conversation with this man, just as humble as he had the night I had encountered him, a beautiful blonde woman at his side, at La Coupole in Paris. That night when I had impetuously said hello, a cold February rain hammering the street outside, he wore a blue knit cap, the kind sailors wear, and an old grey sweatshirt. Simon Lane said, "He was a bit of a rogue with the ladies, compensating for his diminutive stature by keeping to the horizontal." And I can only imagine that the ladies adored him. Durrell and I shook hands and I retreated back to my table, wishing I'd drunk enough beforehand to be able to engage in some sort of repartée. I wasn't very good at that sort of thing at the time. Graham Greene found Durrell's writing highly pretentious. But as I observed him across a sea of heads at La Coupole, I wouldn't have thought him capable of pretension for a second. Now that I've absorbed the atmosphere of his existence in Sommières, I am

certain that he instinctively held whatever pride he had in him-
self in check. Obviously, there's nothing the matter with glanc-
ing at yourself occasionally in the mirror to say "well done."

At the café in Sommières this Saturday morning, as we had a
dozen oysters and a glass or two of rosé, I thought of how that
town, once known as the Paris of the south, inspired Camille
Pissaro to carry on with his limpid experiment, even to invite
the taciturn and befuddled Cézanne to join him there. I pictured
the two wandering aimlessly below the enormous trees that
define the river's edge, wondering dazedly what to paint next.
The atmosphere of the Vidourle is intoxicating, but it never
allows the conscience to rest. The spirit of Durrell in that place
is imbued with the profoundest regret. For a time, for me, this
was a mystery that made me uncharacteristically uneasy. But a
sense of Durrell's regret eventually came to me. It can only be
the knowledge that one day we will be gone, not just from our-
selves and those we have loved, but also from a place so intan-
gible in its beauty as to be very like, in essence, what we want
to know, and will never know, about ourselves.

2.

I was 32 when my father died and he was 63. The doctors had
predicted that he would die 10 years before he naturally should.
This prediction had nothing to do with my father's indulgences.
As far as I know, he had only one, a preoccupation with him-
self. Most people who have a preoccupation with themselves,
from my experience, eventually find their insular lives unbeara-
bly tedious and succumb to the same deleterious distractions
that keep so many other lesser mortals sane – cigarettes, drink,
gambling, sex. Artists, of which my father was one, have in
their art the manifestation of their egos to contemplate day and
night. But my father had pretty much given up his art – he'd
once been a portrait painter of some stature and a sculptor of
undeniable integrity – to become a viable provider for his fam-
ily. He'd become the head of his own advertising firm. This
vocation was in no way alien to him because during WWII he'd
conjured up all of the most pertinent enlistment campaigns for

the US Navy. In this capacity, he was not only obliged to design and paint the artwork for posters and billboards but also to paint portraits of various celebrities – Rita Hayworth, Gary Cooper, Art Godfrey, etc. – in the guise of naval officers for more strategic purposes, like advertisements on the pages of all of the most popular magazines.

Not only was *good taste* my father's middle name but in just a few years on the commercial scene, *elegance* became his constant companion. Rex never, however, lost his visual appetite for the perfectly formed human figure, which in Nietzchian terms he cultivated in himself, and which in romantic terms he found in *Hefnerian* voluptuaries. One afternoon as he and my mother and I drove from our house in the country into the city of Philadelphia, I overheard my father ask my mother what life was about. This was the sort of question that not only frustrated my mother, because she assumed everyone knew what life was about, but more incongruously made her extremely indignant. This was obviously not the sort of unsympathetic response my father was seeking at the time and it was about a year later that he had the horrendous automobile accident that nearly ended his life.

Rex was driving down a road he'd driven down innumerable times before. He wore a suit as he always did when he went to his studio, an old stone farm house perched on a grassy slope about 40 minutes from home. He always arrived before his secretary and designers. As the director of the firm, he occupied a vaulted room in the attic. It was a sunny morning, about 7:30, and the ranch-style houses that flanked the road were sealed tight against the autumn chill. A woman on her way to work, her friend and fellow-worker sitting beside her, pulled her car up from her gently sloping driveway onto the road. She said later that the sun must have been in her eyes because she didn't for a second see my father's blue convertible gliding towards her. The impact was so violent that my father's watch flew from his wrist – its buckle remained fastened – and his oil paints resting in a box in the back seat squirted from their tubes. The door on the passenger's side of the emerging car sprung open

and the woman popped out onto the street smashing her head. She died there and then. Her friend, the driver, crawled over the front seat and went back into her house to call an ambulance. My father's head had hit the chrome frame of the windscreen and his body was folded over the steering-wheel. He would remain in a coma for two weeks.

A day after Rex's arrival at the hospital, the doctors decided to drill two holes in his skull at the forehead to relieve the pressure. No one knew if he would ever regain consciousness. Neither did anyone have any idea what he would be like if he did. I made my way from one bus station to another and from one train station to another to join my family at home – I was attending an art school in New England at the time. My sister was too young to observe our father's condition so I first ventured alone into the intensive care ward with my mother and brother waiting in the corridor outside. The first thing that struck me was how very small my father looked, one hand bound to the tubular arm of the bed so that he could take nourishment intravenously. His eyelids were screwed down tight, eyes occasionally darting from side to side beneath them like those of a man under hypnosis. When I took his free hand he suddenly became very calm. I studied his face. Now it was his hand that held mine, and he tightened his grip. He was letting me know that he knew that I was there. After a while he became distracted and, to my astonishment, began counting softly to himself. This was how he would find his way back to reality, by counting.

When Rex left the hospital he was put in the care of the Seventh Day Adventists who had a clinic in the hills above Reading. He'd grown up in Reading, Pennsylvania. His mother and father were buried there, so this was a kind of destitute homecoming. The injury to his brain had thrown his distant memory into focus and, as far as he knew, both his mother and father were still alive. Sometimes he didn't know my mother, sometimes he thought she was his mother. Strangely, he always seemed to know me and my brother. In the evenings, he'd watch the Viet Nam war on television. He told me and my brother not to have anything to do with it, that it was a truly

horrible thing. Our mother supported the war, which meant that she was often in a much worse frame of mind when we left the rehabilitation centre than when we had arrived. One day, the doctor in charge of my father's recovery told my mother that the shock of the accident would take ten years off his life. My father was 52. He died of a rare debilitating blood disorder ten years later. Only people who have suffered extreme trauma die from this. They just wither away and die.

3.

I had a friend, a family friend a bit younger than my father, whom I took in his Cadillac convertible for his chemotherapy. He was called Jack Connelly and he had only one good arm. If I remember correctly, his useless arm was shattered in the Korean War. Yes, he was an American. He was of course Irish and he sang. He sang at the annual variety show in my town. He wore a tuxedo when he sang and everyone knew there was a metal brace inside his black sleeve. He sang ballads, and he sang very beautifully. He was a handsome guy with shining black hair. His wife was fragile. She was the first grown woman I touched. When I was 9 or 10 I used to rub her neck and shoulders. This was in her sister's living-room when everyone else was hanging around the swimming-pool. There wasn't anything sexual about it. It was ethereal. Her portrait, not a very good one, looked down at us from over the mantel. So, as I touched her, I could gaze into her eyes, even though they weren't really her eyes. They were two people – Jack and Jane – who were determined to live life to the full. He died of lung cancer, but he went on smoking and drinking until the end. On the way home from his chemo I'd pull the big maroon car over to the side of the road so he could be sick in the weeds. It was inevitable, but Jack always apologised for the inconvenience. When they'd lived in Hollywood, he'd been Alfred Hitchcock's dresser. Not only did he dress all of Hitch's major actors, like Janet Leigh, he also dressed Hitch himself. He told me a lot of things between his house and the hospital and back again.

4.

Funny thing, I didn't realise I was addicted to pastis until this morning. My addiction has developed over several weeks as each morning around 11 o'clock I have a drink at the café and pore over *Midi Libre*, our local newspaper. I sometimes read *La Marseillaise* as well. But this addiction has been compounded by my use of Mogadon, which I sometimes take in the middle of the night when I am desperate to escape the insidious sound of my tinnitus. Occasionally, when the tinnitus is excruciatingly loud I wish I were laid out on the dining-room table with my way to that quiet ground finally assured. Nothing would be sweeter than the sound of my friends murmuring mournfully over me, especially as I wouldn't be able to hear them, but most especially because I wouldn't be able to hear anything. I am in such a wretched state that I will have to give up writing for a time, at least until my stomach is no longer a pit of anxiety and this fluttering indecisiveness has left my head.

Two weeks have passed and the cure upon which I deliberated for several days in bed has succeeded: small doses of a very mild rosé throughout the day and at night two tablets of Escholtzia, a herbal remedy for insomnia, at roughly four hour intervals. I've had tinnitus all of my adult life, the result of a product for sinus congestion my poor misguided mother kept in the refrigerator and applied lavishly to my nostrils and my brother's, our heads tilted back over the edge of the bed for in-discriminate lengths of time, each evening before settling down to sleep. This began when I was perhaps four and continued until at the age of nine I was repeatedly sent home from school with the most excruciating earaches. As the other children in class sang patriotic hymns, I wept with pain. Mine is a diaboli-cal condition because the flesh within my inner ear was so erod-ed by the medication that the nerves normally used for hearing are permanently exposed and now instruments of torture.

The sound in my head ranges from sand pouring over a very large sheet of glass to the din of an enormous factory rumbling in the distance. Now and again, there is the piercing whistle of a

tea kettle. There is also the added dimension of what is called *appropriation*, which means that when I'm trying to have a conversation with the person sitting next to me, I'm able to hear what someone across the room is saying far better. I've read that Vincent Van Gogh very likely mutilated his ear not because of a prostitute's disdain but because of the infernal sound in his head. Occasionally, in the middle of the night I'll make my way to the sink in my studio and turn on the tap and stare through my reflection in the window out onto the street. This would be in winter when the windows really can't be open for very long. In the summer, I leave the windows open so that I can hear the fountain down at the corner singing softly throughout the night. My only comfort is our cat Fenton who sleeps by my side. In the mirror in the morning, I see the weariness in my eyes. My eyes are the eyes of a stranger, of another man stricken but subdued. In later life, Goya lived with tinnitus, but he was also profoundly deaf. Some say that the sound that emanates from his *black paintings*, from the gawping harpies and howling deranged sunk in cavernous spaces and fixed against empty devouring skies, derives from the torture that perpetually dominated the interior of the artist's head.

5.

Drugs take people away, don't they? Personally, I like the idea that a drug might be my best friend, although I know that if the drug excludes another best friend I am lost. The drugs I'm talking about have nothing to do with impeding physical deterioration or defeating our malignancy, they have do to with taking ourselves to a place where we can be quietly alone without the malevolent intrusion of our illness. This is of course wishful thinking because our illness has created a new confine for us in which we must live until our illness leaves. Our illness becomes our best friend until it, for one reason or another, grows tired of us. When our illness wants us with a force beyond any reason but its own, we, like all good lovers, succumb. The first woman I ever loved sucked popsicles at the end of her life, a withered but grateful child. This was all she could manage. She died of Hodgkin's Disease, barely 20 years old. She forbade me from

coming into her room. I told her I loved her through a doorway. Our mutual friends gave her a wonderful burial ceremony, I imagine, but it was not an event I chose to attend. Naturally, I was bitter, asking myself how anyone could possibly celebrate a life when there's nothing left of it but pain. That's what I thought then.

<p style="text-align:center">6.</p>

I was 14 years old. I can't now recall if my journey had begun in Philadelphia or New York. I do recall that the train stopped in Chicago on its way to New Mexico. In 1963, Chicago staged a revival of that city's Negro Exposition of 1940, at least that was my impression upon arriving there. I can still picture the large orange posters declaring that Little Stevie Wonder would play *Fingertips* on his harmonica at some momentous public event. I liked the part when he inexplicably tossed in a few bars of *Mary Had A Little Lamb*, but I didn't get to see Little Stevie perform in Chicago because I had to get back on the train and go to Denver, Colorado which would be our next stop. I'd once hopped a train along the river in the town where I spent most of my childhood and had ridden as far as Baltimore. I was missing for the better part of three days and the police were waiting for me on our front porch upon my return. I told them I'd fallen asleep in the woods. Bullshit, I overheard one of the cops say.

My trip to New Mexico, stopping at Denver, Chicago, etc. along the way, was in the service of the Boy Scouts of America. Not only did I have a tendency to go missing throughout my childhood and early teens, I also had a tendency to be served in bars. This was because I looked several years older than I was. At every city where we stopped we were allowed free time, which meant that we were allowed to wonder off of our own accord. If I remember correctly, our train rolled into Denver around 11am. In 1962, Denver was a poor and lonely place, tenanted mostly by losers who hadn't been able to find their way to Las Vegas, perhaps Los Angeles. It was bleak, and the relentless sunshine gave it a filthy unreal character like a plate

of fast food dumped in the street. It really was America at its gruesome best. Instinctively, I made my way to that section of town where the entertainment value was premier. Up and down the street where I'd come to stand were bars, but mostly bars without a view onto the street – in Denver in those days drinking while simultaneously watching girls show off their flesh was thought to be a depraved preoccupation, the sort of preoccupation reserved for unwholesome men with an acute aversion to Jesus Christ. This assumption was of course incorrect because many of the men who frequented these bars were only really testing their metal as good Christian husbands. They were men living on the edge of revelation.

My gaze fastened on a bar across the street which occupied the entire corner, its door cut on a diagonal to the street, two or three wide steps leading up to the door. The one story building was clad in what appeared to be faded purple plywood and didn't have a single window, not even up high near the roof. I dimly heard music throbbing inside. This was much too exciting to go uninvestigated and so I crossed the empty street and approached the bar. As I drew closer, I could see that someone had decorated the door with perhaps a dozen tiny pictures. The tiny pictures were Polaroid snapshots of someone called Lattura. Lattura was wearing an ersatz *harem* costume, its lurid green reminiscent of a beetle's wings coated in granules of sugar. It was impressively skimpy. Her black hair obviously was dyed and her figure was as ample as any mid-western farm girl's. She had a freakish sexuality about her that I found altogether enchanting. It was just as I was contemplating her unnaturally long eyelashes that a rush of noise assaulted me through the door. The door was flung open, pinning me to the wall behind, and a man stumbled down the steps and fell onto the pavement. The man's teeth were bared. I don't recall what he said – and he did say something – because out of the corner of my eye I saw a gun. Now I saw the side of the man's face with the gun. He knew I was there. He shot the man lying on the pavement. The man on the pavement rolled over and the man with the gun went back into the bar. Blood was leaking out from under the man on the pavement, and he began to

twitch. As I rushed off down the street, I looked back to see the man raise himself onto his hands and knees then collapse. The other Boy Scouts and their leaders were waiting at the station, some of them just finishing their sandwiches and sodas. When I got back on the train, I kept what I'd seen to myself.

Alfred Hitchcock, 1960

Guy Lane & Simon Lane, *Twin Portrait No.3*, 1993

A BOWL OF CHERRIES
Simon Lane

"Rage against the dying of the light!" — Dylan Thomas

Monday

I am supposed to be in Rio de Janeiro. But I am not. I am in a
suburb of Birmingham, at the undertaker's, watching the snow
melting at my feet to make a pool of sadness on the carpet.
"Will you be picking up your father's ashes from Warwick?"
asks the man, handing me a small box containing Dad's signet
ring. "Why not?" I reply. "He picked me up from Warwick
often enough. Off the London train."

Friday

We put Dad beside his favourite tree. It is December. England.
Damp, grey landscape, wetness everywhere, seeping into my
heart. How dead can anyone be? I ask myself. Just a pile of ash
at the foot of an old tree, bare branches sticking out, uselessly,
into the sky. Well, he's over the edge now, to the other side.
He's not missing much. He'd have died of the cold anyway. He
must be cold now. Shouldn't we cover him up or something?
Give him a drink? Bury him? What's the point? He's gone and
there's no coming back. He's with me, he'll always be with
me, he's frozen there, on the ground, and he's frozen in my
mind, drink in hand, cigarette in the other, laughing, or walking
across the living room after a long absence, hand proffered like
a gift to shake my own.

Sunday

I don't know what the date is. I hate diaries anyway. As far as I
am concerned it's just another Sunday so the pub doesn't open
until midday. Nothing happens at the moment. I am lying here,

just lying, in this room. All I have is sleep. Dreams. I look forward to going to bed, alone. I take a pill. And then, almost immediately, I awaken. I don't bother to open the curtains, all I will see if I do is another curtain behind them, a bigger one, white, shadowless, infinite, which is England in winter. The dreams take me to places I want to go to and then to others that scare me. I don't dream of my father. My father did not die, he is more alive than ever, he has become omniscient, I can feel him near me as I lie in this bed. Yes, he is sitting there, telling me that life is just a bowl of cherries.

Monday

I am like an express train that has come to a stop in the middle of the landscape. My life is a journey conducted at speed and stopping is like death. Is that why I feel so close to my father? We are both over the edge, in different ways. He is dead, of course. And me? I am half-way to something, caught in a nether world which is neither living nor dying. I once stared death in the face and now it stares at me, taunting me, like a bully, or a man who always wins at chess.

Wednesday

It will soon be Christmas. Christmas with a Dead Father. I slip between the cold outside and the cold within me, my entire being enveloped in dampness. This morning, very early, my mother awoke me. "Come, Simon. Quick! The Morning Star is right over the tree!"

I got out of bed and rushed into my parent's – my mother's – bedroom. And there it was, The Morning Star, shining like a street lamp not an inch over the topmost branch of the tree. "It's a blessing!" exclaimed my mother.

"That's right, Mum," I said, holding her hand and staring, blindly, into the night.

Thursday

I don't know where anything is, my possessions and papers and notes and manuscripts and clothes are scattered in a material diaspora, lost to the corners of a dozen apartments and lodgings in Europe and elsewhere. I have a bag in my room that I brought with me from Rio. But I have forgotten what is in it. I found a pencil in a drawer and took some paper from my father's study. That is all I have. And that is all I need. Later I will go to the pub and drink a pint of Flowers Original bitter.

Friday

I am in the pub. It is lunchtime. I sit by the fire. I am alone, writing this. Jacky comes into the room and goes behind the bar to pour me a pint. Then she sits down to do her crossword. This bar is a hallowed place, blessed with the presence, now absence, of my father. On the ceiling a long, wooden propeller is suspended. One day, the propeller will turn and we will all take off to join Dad. "How are things?" says Jacky.

"I'd say that I miss Dad. But I don't. He's right here with us."

Saturday

Last night, Big Mike told me a story. He once had a friend who lived for parachuting. One day, his friend went out and bought a magnificent silk parachute. He spent all the money he had on it and he was scared that someone might steal it. So he kept the parachute strapped to his back, wherever he went. "That's a strange story, Mike," I said.

"It's not really a story, is it?"

"It'll do."

Sunday

I can't stand the thought of Christmas. So I think of other
things. Now that my life has stopped I can look at it properly,
as if I were in a field somewhere, looking at an express train
stuck in the landscape. I think about women and the past and
the places I have been. I think about Rio de Janeiro and Brazil
and the heat and the way the rain creates a mist which is like
steam rising. And I think about my dead father and my dead
friends who lived in a certain way, for the moment. The dead
live with us. Do we live with them?

It's a Sunday so the pub doesn't open in the evening until seven
o'clock. At five to seven I will get into my father's car and race
through the landscape for my pint of Flowers. The fire will be
going and I will have to wait for Jacky to open up if I am early,
pressing my nose against the window like a child.

When I first drove the car after my father died, I played the tape
that was left in the stereo. And now, each time I go out, I play it
again. And again. Driving along, I am so close to my father that
I find myself turning to the passenger seat, half expecting to see
myself sitting there, saying something.

"I've never known the beer so good, Dad."

Monday

Another Monday. What do they all add up to, these Mondays?
Just a pile of Mondays folded up and hidden somewhere in case
we need to refer to one of them later. "Have you seen last Mon-
day, Simon?"
"I'm not sure. I think I threw it away by mistake. With the bot-
tles."

I lie in the bath, perfectly still, watching my feet as if I were
dead, waiting to be put into a box. No, I don't want a box. You

can cremate me and stick me next to Dad at the foot of the tree. If it's good enough for him, it's good enough for me.

Wednesday

Dad used to read my work in manuscript and tell me what he thought. He was a great reader. I once gave him "The Life and Opinions of Tristram Shandy," by Laurence Sterne, which is England's greatest novel, and he read it seven times. If I ever asked him what he thought of one of my books, he would say. "I don't know. I've only read it once."

I wonder what he would think of this? He wouldn't like the thought of being centre stage, of being the focus of attention. Extravagant and modest, shy and extrovert, kind and intimidating, he was the meeting of opposites, a delightful enigma with a profound sense of life in all its absurdity.

Thursday

I can't stop thinking of the man with the parachute. When I return to Rio I will make a film and play a part in it. I will wear a parachute over my suit and stride onto the terrace of the Copacabana Palace Hotel. Taking a table, I will order a Caipirinha. The waitress will be young and beautiful and I will fall for her. At the end of the film, after the credits, the same waitress will bring me my Caipirinha. I will know it's the same waitress as she is wearing ear rings made of tiny sea shells. But she will have aged fifty years.

Yes, there's a lot I can do with the parachute story.

Friday

This is Christmas Eve. Christmas Eve with a Dead Father. We are staying in a hotel in London. My mother and me. I have a

bottle of wine and I watch a movie on television. I think of my mother in her room, sad, forlorn. Then I go to sleep.

Saturday

Christmas Day. We are joined by my twin brother and his wife. They give me presents, which embarrasses me as I haven't got any to give. Where is my parachute? Later in the day I steal some potted plants from the hotel lobby and offer them with love and seasonal greetings.

Sunday

Christmas has gone, like Dad, but it is still everywhere. I drive my mother home in silence. When we get home, I find the present my father bought for my mother before he died. I give it to her and she unwraps it slowly. It is a scarf. The pattern on the scarf consists of gondolas floating in space. It is very beautiful and Mum stares at it intently for a while. I hold her hand and she cries. Nothing can be as bad as this, nothing can be as poignant. I would never write about such a thing, it is too private, too intimate. Then why am I doing so?

Tuesday

Suddenly, I realize something. My father always wound the clocks. And now they have stopped. They must have stopped days, if not weeks, ago.

There are two clocks, the one on the grand piano and the grandfather clock in the hall. I find the keys and wind them carefully, before setting them.

My father took the clocks very seriously. He was inspired by "Tristram Shandy," for the narrator in the novel describes his father's correctness in "business or matter of amusement." A

creature of habit, he would, on the first Sunday of each month, wind the house-clock, bringing "other little family concerns to the same period," by which he meant that he would make love to his wife.

The order and eccentricity of the story perfectly suited my father's nature. Winding the clocks, I think of him and I think of time. Am I turning the key or is the key turning me?

Wednesday

Everyone is talking about the Millennium. "What are you doing for the Millennium?" they ask. Nothing. I'll just watch the clock and then it will be over. Or I will go somewhere and lose myself in love and drunkenness. Yes, I will get on a plane and go somewhere. Rio, perhaps. No. I am not ready to restart my life, I like it like this for now. I don't write, I don't think, I hardly even read. I am hovering an inch above the dampness of this place, floating upon a sea of tears, with not a kindly mermaid in sight. "O mar, misterioso mar/Que vem do horizonte!" A moment can last a millennium, so I will celebrate each moment with a raised glass and a line of poetry. Or a story from Big Mike.

Friday

My mother gives me a present. It is a photograph from the 1920s. My paternal grandfather, Captain Lane, is standing in front of an open topped limousine, his chauffeur behind him, staring forwards, gloved hands on the wheel.

One night, a year or so ago, I stayed up with my father drinking whisky. I asked him to speak his heart and he told me that he was sad because he felt he could never match his father's example. I told my father that, in his selflessness, he had exceeded it. "You are very kind, Simon."

"I mean it."

My father lived and died a gentleman. On the day he died he went to the pub at lunchtime. He was in good spirits. He told Jacky that I exasperated him in my wildness and irresponsibility and they laughed about me. Later in the day he felt some pain in his back. My mother came home from the races and went upstairs to get some painkillers. When she returned to the study, my father was beginning to lose consciousness. He turned to my mother and said, "I want you to pour yourself a decent glass of Champagne." Then he died in my mother's arms.

Wednesday

It gets dark at four o'clock. January. I remember my father visiting me in Berlin when I lived there twenty years ago. At the airport he showed his passport to the immigration official. But it wasn't his passport. It was my mother's. "This isn't your passport," said the man.

Dad didn't like Germans because they bombed Coventry and he could always see it ablaze on the horizon of his childhood. "What do you mean, it isn't my passport?"

We spent the week-end making jokes about it and my friends in Berlin thought my father very amusing. My father *was* amusing. He didn't need my mother's passport to be so.

Sunday

Memory: my father standing in a street in a small fishing village in Catalonia. Circa 1964. He is holding a bottle of Coca-Cola in his hand and smiling.

Monday

I have been thinking about the piano. The piano died with my father. My father played only a few tunes but he played them as if he had written them. His mother was a concert pianist. She met my grandfather at a "thé dansant" in Buxton, Derbyshire. My grandfather fell in love with her on sight.

My father gave up playing the piano several years ago. He just stopped, suddenly, which is often the way he did things. Without discussion. I never asked him why. There would have been no point in the question as there was probably no particular answer. It was simply his intuition. Perhaps it made him too sad. I will never know, which is how it should be. Now the piano stands idly in a corner of the room, its lid up, expectantly. Silent, forever.

Victoria Cohen, *Amos Poe*, 2008

INTRODUCTION TO A POEM FOR COOKIE MUELLER
BY AMOS POE

*Marcus Reichert in Conversation with Edward Rozzo**

MR: You mentioned Nan Goldin as someone who takes very strong pictures of people making love. Beyond what I consider the compelling beauty of many of her images, she has the uncanny ability to bring a weird haphazardness into play which gives a quiet, disarming depth to the subject. Somehow, she manages to capture people and places together in a kind of collusion which I identify with enormously. Nan Goldin and I had a friend in common, Cookie Mueller, with whom I spent many an endearingly desolate night in New York. I first saw Cookie acting in a film by Amos Poe and found her very sexy. Amos and I were both struggling to make films and so we appreciated each other's particular dilemmas. At any event, Cookie and I eventually met and we spent quite a lot of time alone together, and occasionally in the company of her young son Max. Cookie used to leave New York for days at a time. She used to go to northern Africa with a few of her chums and shoot heroin. She had Berber tattoos on her fingers and shared a needle.

In 1989, Cookie died of AIDS at the age of 40. Her husband Vittorio also died of AIDS due to his own addiction to heroin. Nan Goldin's *Ten Years After* is a kind of gentle exposé of the life Cookie and Vittorio shared. These are supremely melancholy images that have an almost otherworldly fatality about them. But Goldin's work with Cookie carried on until Cookie was dead. These images of Cookie's transformation from vibrant woman to waxen object of fascination were shown at the Whitney Museum and, by all accounts, were harrowing. Cookie may have been reckless but she also had courage. She and Nan Goldin made a statement. I've never been able to look at these photographs. If I were outraged by Nan Goldin's willingness to photograph Cookie dying it would be one thing, but I'm not. I'm just too much of a coward to see Cookie's suffering frozen before me. Somehow I think it would have been easier to be there.

138

*Excerpt from *Art & Ego* published by Ziggurat Books International, London & Paris, 2007

LAST TIME I SAW COOKIE BLUES*
Amos Poe

At Vittorio's funeral, say hello
No babysitter, no problem
10 Months old Lucy
in my arms, Senora says
"she's too young for here"
Dr. Mueller, artist, hobbles in
I hadn't seen her since the stroke
I broke

One time
Eric puking on Cookie's floor
At the MDA convention of 1984
Another time
Cookie walkin' between Sharon and John
Cookie in long hair monkey furs
John Waters laughing next to her
Sharon, hands in her jean pockets
James Dean. And of course Munchen
And Berlin. A cold February, 1981.

Munchen Airport

The Gestapo types had us dead to right
"Beth" was carryin' coals to Newcastle
of course it was all my fault. It was.
If I hadn't
If it was gonna be anybody it was
Gonna be Cookie, but "Beth"?
Yet Cookie is anxious, strangely hysterical, sez:
"Don't worry Beth, you're so Aryan they'll have to let you
go!"
The strip search by Frau Ilsa of the SS
"Beth" was first to go, trembling
Cookie sez : "I'm gonna confess Plead for mercy!"
"What?" I'm shocked, "Confess to what?"
"I got MDA, cocaine, hash and heroin sewn into my bra!"

I'd noticed Cookie looked a little large up there
I even mentioned it to "Beth" –
"Never confess!"
"I don't want to go to a German prison!"
"This is what you do –
when you're in there
take everything off before
you take off your bra – bra last!
Got that?"
"Why?"
"While she's staring at your pussy
toss the bra in with your other clothes!"
"Beth" comes out, shaken, pale, blonde
Cookie's next – stirred to slight of hand
 "Beth" weeps, "What's gonna happen?"
A barking shepherd dog tugs, snarls

Cookie comes out triumphant, maybe a little too much so
Jumping up and down after a strip search
May not be in the best judgement –
Cookie & I are allowed to leave for Berlin
But "Beth" has to stay, under arrest
May be deported, or tortured into confessing
She begs me to stay with her & I do.
Cookie goes ahead alone.

A day of hilarities, tension, "Beth" is
Finally deported to Paris. Poor thing.
I take the last plane to Berlin.
The heartbreak of drug smuggling.

Hotel Savoy, Berlin

I arrive at the hotel the festival has so
Graciously gotten for me
the desk the clerk says: "Mrs. Poe is upstairs!"
Mrs. Poe? What-the-f…
I got the key I go upstairs, sexy hotel
But I can't open the door

Something's back there – jammed
I finally push in, its Cookie lyin'
Face down on the fine carpet
I go into EMT mode, scream
"Cookie! Cookie! Are you dead?"
She sure felt that way – I dragged
Her into the bath, rolled her into
The tub, turned on the shower –
Eventually, she moves, eyes rolling in her
Head, I turn off the water before she drowns
She asks, "What time is it?"
My watch says 11:39 – "11:39!" I say.
Cookie's brain a wonderous beast
"Oh shit, we're gonna be late for the party!"
She slips, slides, stumbles out, dresses
For the party, getting' fixed up, mascara
Finally, I ask, "Cookie what happened?"
"I thought there was gonna be another
customs thing in Berlin so on the
plane from Munich, I went into the
john and I was gonna flush everything down
but then I thought its such a waste so
I just ate everything, snorted it, but there
Was no border check in Berlin! Fuck!
I hate having to score in a new town."

We got to the party in plenty of time –
The party lasted a whole week.

New York, 1989

A few minutes of eternity, tear for tear
I am holding Lucy, sobbing on Cookie's
Shoulder, she's patting my head
Soothing me, I ask, "Cookie
How do we go on?" She leans into
My ear, sez: "Honey its just our bodies
that go, our souls live on. Forever."

142

That's the last thing she said to me.
A month or so later Cookie passed

Only her body.

*"Last Time I Saw Cookie Blues" is an excerpt from the
chapter The Baltimore Sun Goddess from a book-in-progress
entitled *R&B*

Peter Hujar, *Cookie On Her Wedding Day*, 1986

News photograph, *West Bank*, 2000

A CHILD OF DEIR ISTYA
Henry Ralph Carse

Although, in the dream, you ran,
Gasping hard, leaping the rocky intervening ground,
You still could not quite fit your body
Into the narrow space between his chest
And the bullet that raced to kill him.

So now, awake, you let tears slice you thin.
You pare yourself against the barricades,
Polishing your skin against a line of boys with guns.

And so you become, through your days in Deir Istiya,
As translucent and luminous as mother of pearl:
Honed and unbreakable, a woman between the lines.

And if you still wonder what more you could do,
Or why your transparent heart cannot yet stop steel,
Why the thick world out there cannot yet grieve…

Just look behind you into the torn country where we walk.
See us following cautiously between the ribs of vengeance,
into the thin crying spaces you have made for a beating heart.

See our minds and bodies trying, because of you,
To learn his name, to stand for him, to mourn him too.

Deir Istya, West Bank, 6th January 2002

SO LONG GYPSY: ON THE MURDER OF CLAUDE WEISS
Dom Gabrielli

We've only got words,
we've only got words in the face
of all the tyrants who kill words.
We've only got words
in the indifferent mugs
of the tyrant's silent accomplices.
We've only got words, brother.
We've only got words, sister.

To explain how you
got shot down,
to explain how a best friend
got crossed out,
how a heart got stopped
dead in a Parisian suburb –
but with our words,
can we understand how
someone pulled the trigger?
Against the murderers
of your ancestors
dragged across continents,
carted from place to place,
scorned and disgusted,
diaspora of shame,
our brothers and sisters
destroyed by the million –
what have we got now?
Words, words and a gypsy ballad,
only words against
the eternal murders.

And I am to let my body rot
in some hospital yard
whilst the bastards live on?
I say no! I say enough!
We've got to put fists

into our words,
we've got to attack
head on now,
my cousins, even if we
are the eternal victims –
with our balls bloated with ink,
with our cheekbones oiled
against their fists,
with the memory of all
our hearts full of their bullets,
with the memory of your
brains spilled by their viciousness,
with the memory of our
gullets full of their poison,
with their fists and elbows
and kneecaps splitting
our temples and lips,
with the memory of all
their flames and cinders.

I'll put a knee in
their belly of murder,
I'll venture an elbow into
their cosy eyes of satisfaction,
I'll venture some spittle at
their humiliating grins
and snickering,
I'll venture to break my fists
on their sinister technology,
I'll come down in a storm
and blow the whole sham
to smithereens.

Yes, I'll place fists in my words,
I'll deliver the decisive blow.

To murder murder.

150

Death mask of William Shakespeare, 1616

ART AND THE DEATH OF CONSCIENCE
Stephen Newton

What is it that connects the great satirical Victorian dramatist Oscar Wilde in London in 1895 with Adolf Hitler's Propaganda Minister Dr. Joseph Goebbels in Berlin in 1945? Certainly both were fatally mired in unfolding tragedies, that were to engulf them and both displayed a personal courage and fortitude in the face of extreme adversity. But there was a deeper connection: both fulfilled an innate ambition to transform their life into a work of art, specifically into the form of Greek Tragedy. For Wilde, of course, his infamous Old Bailey trial on the charge of 'committing indecent acts' and subsequent incarceration in Holloway and Reading gaols for a period of two years hard labour destroyed him body and soul. He was to die in Paris in 1900 at the relatively young age of 46 years old, only three years after his release from prison. Goebbels died in the carnage and ruins of Berlin in May 1945 aged 48 years old. He committed suicide with his wife Magda after they had poisoned their six children. Tragic art here fulfilling the role as the harbinger of death and destruction.

By all accounts Wilde did have the opportunity to flee the country prior to his trial and was urged by his close confidantes to catch the night boat train to Paris. When he was arrested in the Cadogan Hotel in London, his room was scattered with half-packed suitcases, a testament to his fatal indecision. This has prompted the question as to whether Wilde was actually fulfilling his destiny and the comment that:

'Certainly, the way his life conforms to the contours of a Greek tragedy cannot be entirely coincidental. Replete with portents, hubris, a wailing chorus of devoted friends and the bloody intervention of destiny, Wilde's biography might have been written by Aeschylus; or, rather, penned by Wilde himself, using the great dramatist as his model. In this way he achieved his ambition of turning his life into a work of art.' (1)

Perhaps the work that most exemplifies Wilde's confusion and commingling of art and life, both in terms of his own 'reality' and through the attitudes of his characters, is the famous novel *The Picture of Dorian Gray*. The story of course charts the corruption of Dorian's soul after he has effectively sold it to the devil in exchange for eternal youth. It is the portrait of him painted by the artist Basil Hallward that grows older throughout the unfolding story and becomes grotesque in his place, reflecting every nuance of his descent into decadence and depravity. In effect, the painting completely takes over the role of conscience and in this capacity eliminates the distinction between art and life.

Isobel Murray's introduction to the 1974 edition makes this abundantly clear. She discusses the corrupting influence exerted by the character of Lord Henry Wotton on the young and impressionable Dorian Gray and his admonition 'to treat life in the spirit of art.' Murray describes how Dorian reacts to the death of his young sweetheart Sibyl Vane:

'By the time he hears of Sibyl's death, Dorian is sufficiently corrupted by his mentor and his own "unconscious egotism" to suggest for himself that Sibyl's suicide, which momentarily affected him so much, is not really distressing.' (2)

Murray goes on to quote Dorian when he says:

'It seems to me to be simply like a wonderful ending to a wonderful play. It has all the terrible beauty of a Greek tragedy, a tragedy in which I took a great part, but by which I have not been wounded' and further notes how in his reaction to this comment 'Lord Henry reasons on until he has eradicated any distinction between art and life...' (3)

Towards the end of the novel Dorian Gray murders the artist Basil Hallward who had painted the fatal portrait and whom Dorian holds responsible for the misery it had generated. But even in the aftermath of this murderous deed, as Isobel Murray points out, Dorian 'treats death in the spirit of art' and ulti-

mately '...tries to escape into art' by reconciling the act through a poetic diversion. (4)

In a final act, motivated by a delusion that he could break free from the past and absolutely eliminate all conscience and re- morse, Dorian destroys the picture. But in the act of stabbing his own portrait, he also stabs himself through the heart.

Joseph Goebbels, 1937

If Wilde's protagonist was destined to treat 'death in the spirit of art,' then so too was Hitler's parasitic acolyte, Joseph Goeb-

bels, who likewise sought an escape in the anaesthetic of art and furthermore to stage the death throes of the Third Reich as a Wagnerian 'Twilight of the Gods.' Goebbels preferred to view the cataclysmic events in the early months of 1945 as a Greek tragedy: it should be remembered that the German philosopher Nietzsche's seminal work on modern aesthetics *The Birth of Tragedy* was dedicated to Wagner and that he regarded Wagner's operas as the true successors to Greek tragedy.

From its very inception the Nazi regime's fate always seemed inextricably entangled with art, steeped as it was in an obsession with aesthetics. Certainly in his role as Minister of 'Enlightenment and Propaganda' Goebbels recognised the power of art to manipulate mass consciousness and to screen reality. He had supported the film work of Leni Riefenstahl, perceiving the mesmerising potential of her films such as *Triumph of the Will*, an incredibly atmospheric evocation of Nazi doctrine. Nevertheless, in the midst of the horrific realities of the war's end, it is hard to believe that some of the key members of the Nazi hierarchy were still dabbling in art.

As the Russian armies prepared to encircle Berlin and bring rape and pillage to the capital and whilst ordinary Berliners had no water or electricity and often resorted to carving meat off dead horses for food, Albert Speer, the erstwhile armaments minister and Hitler's architect was organising a concert by the Berlin philharmonic orchestra of Wagner's *Gotterdammerung*; Hitler by all accounts spent much of his time redrawing his models for the future Reich and world capital 'Germania,' a Pan-German city designed to evoke and surpass the imperial majesty of ancient Rome. Meanwhile, at the propaganda ministry, Goebbels was hosting a private screening for an invited audience of party functionaries of the film *Kolberg*. Specially commissioned by him, the film reconstructed the valiant defence by earlier inhabitants of the town against Napoleon's armies some hundred and fifty years previously and was intended to stiffen the resistance of the German populace against the invading Soviet forces.

The film was beautifully crafted with the bright red and blue tunics of the French infantry set against the stark clear north German light. It has been recorded that film extras were killed during the making of the film in battle scenes involving explosives, although the production wasn't held up at all and that frontline troops were actually withdrawn from the Eastern front to act as soldiers in the battle scenes. The film's atmospheric treatment and cinematography pays homage to Sergei Eisenstein's masterpiece *Alexander Nevsky*, similarly commissioned by Stalin as a propaganda instrument. Whilst *Kolberg* was on more general release in German cinemas in 1945, the actual town of Kolberg on the Baltic coast in Pomerania, was besieged by Russian troops. The population was evacuated by sea, although this inconvenient truth was not divulged to the wartime cinemagoers.

It is hard to imagine that during such desperate shortages and in such a critical and apocalyptic endgame, resources could be diverted for such a lavish film set. Goebbels put great faith in this project and, of course, it is a matter of record that Hitler himself was an avid film buff, spending many nights both before and during the war screening sentimental Hollywood films into the early hours for his intimate circle. Hitler has been compared to the Roman emperor Nero, who 'fiddled while Rome burned' and he certainly shared with Nero an almost childlike faith in the power of art to somehow transcend the immediate terrors of awe-full reality. (5)

Wilde, Goebbels, Hitler and Nero all were seduced by this siren song. It is, of course, a grievous injustice to Oscar Wilde to taint him by association with such an unsavoury and infamous grouping. He was a brilliant classical scholar, winning the extremely prestigious Newdigate prize at Oxford in 1878 and (by his own admission also) was a genius as a dramatist and critic and is of a totally different order from the others. But it is nevertheless true that Wilde seemed to believe, as is witnessed in much of his writing and discourse, that aesthetics would always 'paper over the cracks' of his dysfunctional private life; that he could always call upon sympathy and indulgence because of his

exceptional talent and special place in humanity as an artist of the highest order.

Aesthetics would mask his own depravity and forever grant him the right by virtue of his literary brilliance to live as he saw fit, encompassing the rounds of rent boys, or 'renters' as he refers to them in *De Profundis*, and the general debauchery which came to light during his Old Bailey trial. This again is the central theme of *The Picture of Dorian Gray*, where Dorian's depravity and callousness and ultimately conscience are subsumed and absolved through art. Art administers life's vicissitudes and, as Wilde states in *De Profundis*: 'I treated Art as the supreme reality, and life as a mere mode of fiction...' (6)

For the record, Joseph Goebbels was also a man of culture and the most educated of the senior Nazi leaders, obtaining a DPhil from Heidelberg University in 1920. However, it obviously remains true that the aesthetic veneer he created masked a far grosser and criminal depravity than that of Oscar Wilde. What links the group ultimately is the belief that art can eliminate conscience. Nero believed his subjects would forgive him anything for his creations and if they failed to do so, were not worthy to live. Wilde's painting of Dorian Gray is intended to give himself absolution in his 'Art as the supreme reality' as much as his eponymous character. Ultimately, it was Hitler who made the telling comment: 'Conscience is a Jewish invention' and exhorted his cohorts to be ruthless in the eradication of 'sentimentality,' by which he meant conscience.

From this perspective at least, the strange realisation dawns that in the 'Alice in Wonderland' world of Germany's Third Reich, Hitler actually becomes the grotesque real-life mirror reflection of Dorian's portrait. In other words, he assumes the mantle of Germany's conscience and this in essence is his fundamental attraction to the population. He becomes Nietzsche's 'overlord' and the populace is absolved of any guilt for Germany's actions, or need to question its motives or morality. Hitler is a preacher; a Messiah who takes upon himself the worldly sins of others and in that capacity is prayed to and worshipped. As the

Reich crumbles and the German war machine disintegrates, Hitler, like Dorian's portrait becomes increasingly ever more hideously repugnant, with a stooped and shuffling gait, uncontrollable tremors and paroxysms, disgusting personal habits and frighteningly violent tempers. His true face is revealed. Like the ghastly cockroach in Kafka's *Metamorphosis*, Hitler crawls and shuffles around his underground burrow. As with Dorian Gray, suicide is the only escape from the nightmare.

As I have noted, Isobel Murray considered that it was not only the decadent influence of Lord Henry Wotton that corrupted Dorian Gray, but also his own 'unconscious egotism.' The same thing is clearly obvious in the case of Hitler, whose megalomaniacal ego was the underlying cause of his downfall. His eternal faith that providence had proclaimed him the chosen One, was in the end just a product of his monstrous egotism.

Hitler's belief in his own ego through art and his recognition of art's religious connotations goes back to his earliest days in Vienna in 1909. Michael Fitzgerald notes that for the young Hitler art '…was to become an obsession with him' and that:

'…Hitler's conception of himself as an artist dominated every aspect of his life, even after he came to power and even as the Russian tanks were closing in on Berlin.' (7)

As a teenager Hitler was immersed in art, visiting the opera, writing poetry and drawing, with further aspirations to become an architect and producing some impressive and ambitious schemes for various projects. True to form he attended every performance of Wagner in Vienna that he was able to. Other composers such as Beethoven, Schubert and Mendelssohn were also greatly admired by Hitler.

Throughout these years prior to the First World War, Hitler scratched a meagre subsistence through art: painting pictures and postcards for sale, designing advertising posters and painting pictures for frame makers to exhibit in the frame. That is to help sell the frame itself, much in the same manner that photos

of film stars might be used today. However, he of course hoped for greater things and his well-documented rejection by the Viennese Academy of Fine Arts, despite two applications, embittered him and fuelled his resentment. After his second rejection 'He spoke wildly about blowing up the building with the academicians inside it.' (8)

Such an anecdote lays bare the seeds of the utter ruthlessness at the core of Hitler's ego. But ultimately it also begs the questions: Why was he so desperate to become an artist? Why would an individual with such a barren mentality, wholly devoid of compassion, be attracted to art? Or again, why would someone who aims to mercilessly expunge all conscience want to become an artist?

One critical aspect integral to being an 'artist' is that the creative act involves the potential to twist and deform concepts of reality according to personal subjective will. The blank canvas, for example, affords the painter with virtually absolute options and freedom from constraint not possible in reality. Twentieth Century modernist movements such as Expressionism, exemplified the potential of art to bend and subvert reality according to the subjective whim and emotion of the painter. Moreover, modern art was in effect an analysis of the creative process and it uncovered a powerful sense of omnipotence and absolute power at the centre of artistic endeavour.

Modern art, especially through its most radical and unique manifestation, abstract painting, excavated the very mechanics and essential structure of the creative process in its transitional and transformative stages. What this revealed actually verified much psychoanalytical and anthropological research undertaken last century into fundamental human development; that is to say, analysis of the earliest stages of infant psychological growth, displayed exactly the same phases as are to be found in the creative process. Likewise, anthropology reveals the self-same framework to be found in essence in all cross-cultural tribal ritual process everywhere and as far back as the dawn of human consciousness. (9)

This is maybe not so surprising as it might initially appear. Obviously, if a tribal culture wishes to initiate a member of the group into another stage in life, such as adulthood, or marriage, it makes sense to utilise the formats provided by nature herself to develop the human infant. However, what modern abstraction revealed was the blueprint for the trance experience always found at the core of evolutionary ritual. It is the trance experience at the heart of the ritual that enables the initiate to effect psychic change and transformation. Research shows that as the conscious faculties are subsumed within the matrix of the trance experience, a mind-altering experience can be engaged with. There is an exact correlation in the creative process: at its nucleus is a stage of trance experience as the mental processes of the artist are mirrored within the artwork, which effectively, momentarily, takes over the mind of the painter. As this occurs the painter can sense the same fleeting loss of consciousness undergone by the tribal initiate, who was brought to this stage of 'mental breakdown' by more extreme measures such as sensory deprivation.

This momentary trance state potentially at the centre of the creative act confers a feeling of ecstatic omnipotence and absolute freedom upon the artist, or indeed possibly even upon a receptive audience. Such an instinctive and seductive sense of the possibility of absolute freedom of will, must surely have unconsciously attracted the young Adolph Hitler perhaps far more than most attracted to the euphoric essence of art.

Furthermore, this short-lived sense of unconsciousness is experienced as a 'trance-death,' or death of conscious awareness and is often referred to by anthropology as the 'little death.' This is essentially the close nexus between art and death, but it is also a 'psychic death' prior to a new consciousness in a 'psychic resurrection.' It is this hidden religious dimension within a creative 'death' and 'resurrection' that can further be so attractive to the mystic or messianic ego. Religious narratives can be traced back to the earliest ritual procedures and in this light it is hardly surprising that the aspiring young artist Hitler would eventually conspire to transpose the potentially omnipotent will

160

and 'psychic resurrection' of the artist's creative process into a grotesquely deformed version in reality itself, in a regime based on the panoply of religious ceremonial and where art and death were always at-one with one another.

It should be understood that the ecstatic, omnipotent trance state at the core of universal ritual and the creative process, is rooted in the critical formative developmental phases of the infant and serves a crucial function in initiating the infant into a further stage of maturity. Its origin is therefore absolutely natural. In the tribal ritual the initiation, for example, into adulthood would follow the same format. Interestingly, if it is to free the initiate from parental authority, then as psychoanalysis has shown it must at some point negate conscience, originally internalised through that self-same parental control and sanction. (10)

So the potential to neutralise conscience within the creative process is again what must have been so unconsciously alluring to Hitler. Goebbels also must have must have viewed his civilised and cultured preoccupations as a means to assuage the barbaric realities of Germany's actions. Similarly, it is significant that Oscar Wilde chooses a *painting* to absolve Dorian Gray's guilt. For he predicts what the modern abstract painting was to demonstrate.

It is ironical that the very type of art that genuinely affords access to the deepest levels of the mind, where conscience and unconscious processes can actually be reformulated, was the type of art branded by Hitler as 'degenerate.' What he could not realise was that it is only in the intrinsic formal language of painting, in its own painterly language, that conscience can be eliminated. This is a complex process but suffice to say here that abstract painting such as abstract expressionism, for example, tended to obliterate those very deliberate and conscious shapes, lines, compositions and determinations that are the surrogates or representatives of conscious activity. As these are negated and subsumed within an unconscious matrix of indefinite, vacuous, oblique and diaphanous superimpositions, con-

sciousness or conscious control is weakened in the creative process and can be pushed to the point of breakdown.

Hans Namuth, *Jackson Pollock*, 1950

Abstract art, of course, dealt exclusively in art's own form language without any recourse to a representational or narrative dimension. Paradoxically, however, in this pure, aesthetic realm, some essential underlying dynamics pertaining to the real world are isolated in a type of crucible. For whilst it might superficially appear that these deliberate and conscious representations of shape and line are just that, in the authentic artwork they

carry a far deeper significance for the mind. It can be said that for key adaptive and evolutionary imperatives, the mind always aspires to perceive as clear gestalts and shapes as possible and to eliminate any inarticulate, vague or obstructive aspects that might interfere with such clarity of perception. Naturally, as Man evolved on the wild, it was understandably useful for the mind to be able to see and read the outline shape of a potential predator or other danger as quickly as possible.

What is significant here, is that the mind, in order to continually protect and 'shore up' this clarity of vision in its rational and logical aspect, attaches guilt feelings to any actions threatening to dismantle such conscious constructions. Conscience is there-fore innately rooted in this psychological process. The fact that the abstract painting can isolate this physiological dynamic in pure shape and form means in effect that conscience itself can be mediated within the creative process. Furthermore, as indicated, in abstract expressionism, where composition is dispersed 'all-over' the canvas surface and where shape and line can often dissolve into the painterly matrix, a point of breakdown of consciousness can be reached within the analogy of the painting and in turn generate a reciprocal reaction within the mind of the painter in which a trance-state can be induced. (11)

Although through a somewhat truncated version of these creative events, it should nevertheless be recognised that the creative process within a painting can both eliminate conscience whilst inducing a trance-state. In art throughout human history this has been a positive, therapeutic and *trance-formative* scenario to promote psychic rebirth and maturational growth. But in the distorted consciousness of an individual like Adolf Hitler, such factors are seductive for other purposes: to deal with conscience in the absolute and further to access the blueprints for the religious foundations of 'death and resurrection'. This must have been at least in part the unconscious motivation for Hit-ler's obsession with art. However, in the fact that Hitler's sentimental, quaint and rustic little paintings exhibit an absolute rigid conscious control of all technical and formal factors (much in the same way that psychotic art tends to cling desper-

ately to surface logic), it is obvious that he would never have been able to gain access to a creative dimension where conscience could be engaged and confronted. Instead he resorts to eliminating conscience in the real world and in so doing, also turns his life into a kind of art, even if it is a bitter and vengeful psychotic art.

Hitler cannot eliminate conscience anymore than Dorian Gray can. Oscar Wilde, as an artist, tries to deal with his own conscience through his art, but in the end must face the impotence of art to transcend life. In the end Dorian Gray has to face his conscience and judgement. By converting his real life into a Greek tragedy, Wilde accepts the inevitability of trial and judgement by a social conscience. Hitler expects to avoid this by adopting the pseudo-religious role of universal conscience: to take upon himself the sins of Man. In effect he also becomes the picture of Dorian Gray and is ultimately destroyed in the same manner.

Inevitably this raises again the age-old question that has been asked before: was it ultimately Hitler's failure to negotiate his personality through the creative process that compelled him through a megalomaniacal ego to re-orientate the whole world to match his own underdeveloped psyche. For as psychoanalytical research into and analysis of infant development revealed, if there is a failure to negotiate levels of aggression and conscience and a mature acknowledgement of reality, either in these crucial early stages or in a second chance as they are reconstituted in both art and ritual (and in a pseudo-simulated form in religion) then the ultimate seeds are sown for a deformed personality in the adult.

Where art is taken literally and its intrinsic potential to neutralise conscience is transposed into reality, death and tempests seem to result. Hitler's obsession with art and his ruthless annihilation of conscience conspired to bring the whole world down upon his head. It would have been better for Hitler and the world if he had read Shakespeare's final play, *The Tempest*, for Shakespeare, that master of understanding of human nature,

understood that whilst art *can* erase conscience, its real role in the evolution of human society is to mediate its force; to negotiate tolerable levels both for the group and for the individual.

In *The Tempest*, therefore, Shakespeare's leading protagonist Prospero, as ruler and absolute despot of his island realm, ultimately displays compassion and forgiveness even against those who had deeply wronged him and had conspired to kill him. He evokes magical, alchemical powers to bring down tempests at will on those responsible for his unjust exile, to wreck there ship and force them ashore onto his island, but only so that they must show contrition and in return receive Prospero's forgiveness.

Shakespeare's play, first performed for James I at Whitehall in 1611, through its deep understanding of human character, is an uncanny foreboding of Hitler's Third Reich. For Shakespeare knew the demonic and destructive potential of the human ego. Prospero was an absolute master through his control of magical creative spirits; but Shakespeare, in his empathy with the creative process confers upon his characters spiritual growth and alchemical change, the seventeenth century's version of creative *trance-formation*.

It is fascinating to speculate what the film-addict Hitler would have made of Hollywood's reworking of *The Tempest* in the fantastic science fiction film *The Forbidden Planet* made in 1956, just eleven years after his suicide in the bunker. The film, although clearly based on *The Tempest*, is made of course in a post-Freud and post-Hitler era and in the absolute knowledge of what havoc the human ego can wreak.

In the film, Prospero's character becomes Morbius and his island is transposed into a planet in deep space. Morbius, like Prospero, is the ruler and despot of his island in space and with the exception of his daughter, is the sole survivor of a scientific expedition of some twenty years before. All of the other members of that original party died in mysterious circumstances. A rescue mission arrives from earth to search for survivors and is

met with a hostile reception from Morbius. The members of this second party again begin to be killed off by an unknown and unseen force. A type of tempest is whipped up on the planet's surface from time to time, especially if the absolute authority of Morbius is in any way questioned or challenged, as when his daughter, in the role of Miranda in *The Tempest*, develops a love interest with the mission's captain. Finally, it is discovered that the malignant and violent force raging across the planet threatening the lives of the crewmen, is in fact Morbius's own ego, which he has learned to project far and wide by accessing the advanced knowledge of the planet's ancient culture, the Krell, now extinct.

It is left to the captain to explain to Morbius that it is actually his own vindictive ego that is on the rampage, creating 'monsters from the Id.' The fatal recognition of this unpalatable truth sets his ego into overload and the invisible, fearsome forces slowly and inexorably encroach upon the residential compound, which just like Hitler's underground bunker network, forms the last bastion of a defensive system of huge impenetrable metal barriers. In the final stages of the film, each huge metal barrier is one by one smashed through by the force of Morbius's unstoppable ego, the final one being heated to white heat before it too eventually succumbs, leaving Morbius at the mercy of the force which murders him. Just like Dorian Gray, Morbius is compelled to commit suicide by his own mind.

Like Hitler and Nero, or Wilde's tragic and fatally flawed Dorian Gray, Morbius is in the end overwhelmed and obliterated by his own unconscious ego. Morbius, like Prospero, became the arbiter of conscience within his domain, but unlike Prospero cannot display a benign and compassionate forgiveness to his fellow men. Whereas Shakespeare reveals through Prospero how art *should* function to determine the force of conscience, Morbius, in the shadow of Hitler the failed painter, shows what happens when this archaic role of art is overridden in favour of the imposition of the individual ego. Art's evolutionary function as arbiter of social conscience, through artefacts encoding universal ritual procedures, or painterly icons, has been cri-

166

tical and indispensable throughout human development. If the delicate mechanism of the creative process, with its 'psychic death and resurrection', is transposed into a literal interpretation, art's intrinsic and transformative 'death,' becomes a veritable tempest

NOTES

1. Thomas Wright, *Oscar's Books*, Chatto & Windus, London, 2008, p.228
2. Isobel Murray, Introduction, p.xiv to Oscar Wilde, *The Picture of Dorian Gray*, Oxford University Press, 1992
3. Ibid., p. xiv.
4. Ibid., p. xv.
5. See Donald Kuspit
6. Oscar Wilde, *De Profundis*, in *De Profundis, The Ballad of Reading Gaol & Other Writings*, Wordsworth Classics, 1999, p.56
7. Michael Fitzgerald, *Adolf Hitler – A Portrait*, (Spellmount, 2007), p.29. For an account of Hitler's years as a struggling artist in Vienna and Munich before 1914, see also J.Sydney Jones, *Hitler in Vienna 1907-13 – Clues to the Future*, Blond and Briggs, 1983
8. Ibid., p.31.
9. I discuss this in far greater depth in my latest book, *Art and Ritual: A Painter's Journey*, Ziggurat Books International, London & Paris, 2008
10. See Stephen Newton, *The Politics and Psychoanalysis of Primitivism*, Ziggurat Books, London, 1996
11. For an analysis of this aspect of the creative process, see my paper, *Guilt in Painting* in *Art Criticism*, vol.13, no.2. State University of New York, 1998

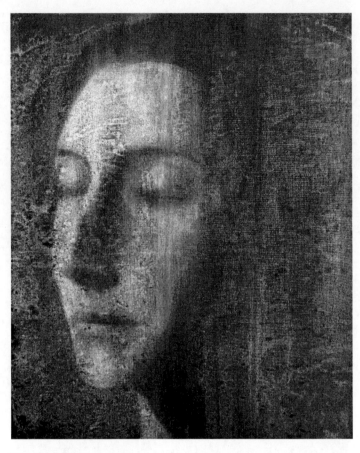

Piers Faccini, *Witness*, 2007

SEARCHING FOR NO ONE
Piers Faccini

Unravel little ball of string
Untie yourself
And walk as Lazarus did from
The grave of your own making

He was alone. Nothing was working. Now only a last lingering
memory of what it was to hope for something better kept some
illusion of a life spluttering forward. Yet behind the numb car-
tilage of what seemed like a lifetime of failure lay a sense of
something strangely comforting, like a pervasive and forgiv-
ing warmth creeping into the cold heartland that had, as long
as memory stretched back, been enveloped in the frozen throes
of an endless winter. More and more he felt as if he were say-
ing goodbye to something. That something, he had come to see,
was himself. Today was just another day among other days,
going nowhere.

This morning he had watched consciousness stir itself from the
void of deep sleep bringing with it the first sensations of the
day, the room lazily pulling itself into focus, his head heavy on
the pillow, traffic passing on the road outside, the familiar dull
pain in his back followed by the usual run of thoughts crackling
like interference over a radio signal. Thoughts racing forward,
jostling for space and with them, in them, like tiny bubbles
bearing news with the customary accompanying dread: *This
feels wrong. This is not quite right.*

Moments before, sleep had held him in blissful annihilation and
now as he awoke the world appeared before him and he along
with it and in this skin in which he found himself each waking
moment became nothing more than a continual burden, like
some ill-fitting suit that was daily forced upon him to wear.

Since he had taken to staying in his room, he had come to many
startling realizations. The room had become his very own ver-
sion of Plato's cave and across the rough watery rock of his

mind candlelit silhouettes like dancing harpies drew their merry turns of hypnotic confusion for him each day.

Who am I? Was this not the only true question with all others being merely branches spreading from the bewildering ancient root of all interrogation? As far back as he could remember, this had been his quest. As if the very first memory registered in his infant's mind had been the sound of those three words: *Who am I?*

He had come to the conclusion that the character he had until now mostly unsuccessfully believed himself to be was nothing other than a grand imposition of the most fraudulent and grotesque kind. It was this new understanding that had driven him to his room. This *he* that he had hitherto so invested in no longer held much sway over him, this *he* had become a ghost but where did that leave him?

He had retreated, he needed only silence. Silence in which all this confusion might unravel. He had only a sense that whatever was happening was merely unfolding in the way it was supposed to. It felt strange for him of all people to feel this, yet more and more his instinct was that things were being taken care of. This was a new and unexpected development. He had always despised faith and those that believed, church and temple goers of all religions, who signed up to a creed and in so doing put aside the fundamental right to know. Faith was for sheep but not the lost kind, not lost as he was, having put aside all religions and having found himself in a desert without a compass, only a thick blanket of raincloud veiling the stars. Belief or faith was just more darkness for the nearly blind.

So it couldn't be called *faith* that he had registered in himself, more a sense that whatever this life was, it was rolling inexorably on in the manner suited to it until its allotted time would be rolled out. Yes, he mused, this life was like a carpet laid out for some imaginary dignitiary to step onto, only the monarch was never to arrive. A red carpet for no one.

This life was indeed a slow dying but now he was dying alive, dying to the tune of the idea of himself he had had all these years. That particular melody had whistled from his first conscious moments and had held him entranced like some snake charmer. But now the effect was wearing thin, the snake had turned on the charmer, barely lifting its head to acknowledge its master. His body was in adequate health yet without question now, he was dying.

•

He rose from the bed and walked slowly over to the basin on the other side of the room above which hung a small framed mirror. He splashed water over his face and then squeezed the end of a toothpaste tube pushing a small lump over a well-chewed toothbrush. Having run it under the tap, he closed his eyes as he let his hand mechanically work the brush over his teeth. His mind drifted with the sound of the brushing. As he stood there bent over, he observed how when his attention strayed to a thought the brushing seemed to cease altogether, although he knew it to be carrying on. It was as if whatever action was occurring disappeared whenever his attention strayed from whatever it was he was involved in at that precise moment. He paused to register this unexpected turn of events. Then, wanting to digest further this newfound shift in his daily observations of himself, he turned his focus back to the task in hand.

Again he watched the shift, the toothbrush working the teeth, the sound reverberating in his head, the arm moving in small rythmic pushes and then a thought barged all previous sensations aside, this time from yesterday, a memory replayed, how he had frozen when the young girl at the checkout till in the corner shop had told him how much he owed her for the half pint of semi-skimmed he had set on the counter. How her words had seemed like babble, suddenly like a sound without any sense whatsoever. Eventually he had reached into his pocket and searched for the feel of the heavy pound coin, then had slowly placed it in her open hand and waited blankly for his

change. He remembered the startled look in her dark eyes.

Now the toothbrush came into focus again, and he felt his bare feet on the rough pine floor, his arm beginning to feel heavy. He stopped and opened his eyes. For how long had that particular thought held him, could it even be measured while it had held him transfixed? Where had the room gone, where had he gone? He shuddered as if the blood had momentarily raced at twice the speed under the impact of this synaptic shockwave. Not only do I exist less than I had expected but so too this room and the world along with it. I am but a thought, and this world too, he said to himself, bending over to gulp in the running cold water, to rinse his mouth clean. A thought within a thought within a thought.

He had read somewhere that life had been likened to a dream, and now in the light of that simple daily routine, he began to apprehend the true weight of those words. If I am a dream, who's the dreamer? He turned and stepped over to the small wooden table to the left of the basin and reached for the white kettle and emptied it of the water inside. Having filled it, he stood there, his eyes closed focusing on the sound of the water slowly boiling. The room reeked of loneliness. Threadbare curains hung limply from the rails, circling stains of damp drew random patterns on the bare white walls. Light from a pale winter sun crept through the cracks in the shutters. Clothes worn the previous day were roughly folded over a wooden chair. By the bed, a pair of brown leather shoes lay pointing towards the door, waiting for a phantom form to shuffle a makeshift life into them.

Edmond Jabès (date unknown)

THIRST AND THE SEA: DEATH AND THE POETRY OF EDMOND JABÉS
Dom Gabrielli

Edmond Jabès fled his homeland Egypt during the persecution of the Jews in the 50's and his whole *oeuvre* is informed by the notion of the foreigner and a deep interrogation of language and its relation to identity culminating in a poignant exploration of emptiness and God's absence. His language is beautiful and enigmatic. Identity is ever lost. Love is a cry and a song before being poetry. Jabès' introduction to poetry coincided with his discovery of death. He discovered there is a language of death, words which rise from the vacuum death leaves in life. Jabès' sister died in his arms from tuberculosis at the age of fifteen. But never does his poetry invoke the pathetic nor the painful. His images recoil before bad taste. His credo could be summarised: Love must be honoured beyond death with poetry. Moreover only poetry can honour love. Poetry resurrects love from the grip of death. We are foreigners, yes, but more particularly we carry the dead into life, we live our lives to continue the lives of those who unjustly passed away. *Elle vivra de ma vie.*

Jabès seems to abdicate all forms of personal autonomy in the pursuit of a language which is always on the verge of disappearing into darkness, a language despite its author, beyond his worldly intervention, a mystical prose crossed by visions and illuminations. Words fill the desert, the desert empties words. *Unknowing does not come before knowing but very long after.* Jabès writes from beyond himself, from behind and beside, from the depth of his unknowing. In his work, aphorisms follow imaginary debates and dialogues, poems shine, gems for the future. Without hatred, adverse to all manner of violence and revenge, his very particular narratives weave mysterious webs of a future wisdom which heralds an immemorial past. Only then can we speak with the dead.

Words sometimes lie in order to seduce.
The book never.

To all races of persecutors whatever their creed, his challenge is unequivocal:

> *May your thought be not a blade that kills, but a simple*
> *nourishing blade of wheat.*

Being is at the heart of the question and questioning at the heart of being. In his *Book of Questions*, his characters voice myriad interrogations. Who can renounce himself for words? Who can live without identity? Without destroying the language of the other? Who can accept the foreigner and welcome him inside himself, recognizing himself as that selfsame foreigner? How can one live without turning our anger against ourselves at our frustration and pain? How can we accept God in his absence? Words are our only answer to this unending labyrinth of questions.

> *He said to me: 'You see, I have no face. The one I am*
> *showing is a face of the moment. The writer is a foreigner*
> *precisely because, to reveal himself, he must borrow a face*
> *from language...The writer is the foreigner par excellence.*
> *Denied domicile everywhere, he takes refuge in the book,*
> *from which the word will evict him. Every new book is his*
> *temporary salvation.'*

And finally, the desert. Nothing but sand, grains of sand. That's all we ever were and all we'll ever be. Sand and the soul between.

> *– God's indifference toward us is perhaps only neglect of*
> *His responsibilities to the world*
> *– Is God so cowardly?*
> *– No. But having lost His way, He fell into the abyss He*
> *looked out on.*

Art as the only response to death, art as the final buffer against impossibility, the hope against hope that poetry can resurrect a loved one.

Jabès, with the highest charge of emotion, with the deepest regret and anger, manages to keep language humble and kind. He controls his own fears as he asks the impossible. He knows there are no answers and that the poet's mission is simply to come close, to approach the question, to encircle it with words. Only art can come close. To question the question. To make as few mistakes as possible in choosing which question to question. Only then can his questioning enter the infinite history of questioning which writing is. Writing teaches us why we approach one question rather than another, as the poet opens himself to being as a multiplicity of questions.

> *The questioning of words is at the origin of the word,*
> *as if questioning of being always preceded being.*
> *Origin means, perhaps, question.*

One summer's day in the market place, a man walks up to the poet. He seems invested with a mission. He asks if he could ask the poet a question. His voice is uncontrolled, he is stuttering. Once he manages to control his nervousness, the man rattles out not one but a series of questions, each one stemming from its precursor:

> Can you live after death?
> Can I live for you who died?
> Can I take a piece of your death with me in life?
> Should I die for you, for the suffering of you?
> Would my death compensate yours and bring you
> back to life?
> Why did they take you before you lived?
> Where do you go now?
> Where do I go now without you?
> What hears the suffering I have inside?
> What can rid me of this anger and bring back my hopes?

The poet listens patiently and replies thus:

> *I am a question for you who are no longer,*
> *I am a beach for a sea without tide.*

Cold marble face.
Eyes of stone.
Ears of dust.

But hurriedly once more, the man's questions return:

Is this why I write? To invent a sea
which hears your forbidden voice?
Is this the definition of poetry,
as response to impossible questions
without which I would die?

And the poet rejoinders:

Is it for me to hear that I write you
who cannot listen?
Is it for the impossible that I live, for the complicated,
 for the unattainable goal?
For the sand which makes me silent, for the wind which
makes me sing.

Thirst and the Sea
Poem by Edmond Jabés

You must not move
You must not breathe
You must stay seated
before me
like the tree and its shadow
like the sky with the sea
as wise as the air
and the sand
at midday in summer
You must not speak
You must not smile
or cry
I must try and guess your name
translate your thoughts

into images
sing your gestures
love you
before you lived
You must not try
and understand
you must not get up to leave
when you are tired
I have scattered the roads
I have drowned the signposts
There is nothing left but
empty space
just night
between you and everything
You must not rebel
You would break the lamp
shining on your lap
you would lose the world
and we would no longer know who we were
One evening
I imagined you dead
and you had these same eyes
looking at me
the same burning stones
which go prowling with the wolves
in dark green forests
You had the same
useless hands
the same worried brow
the same crossed legs
and the same dishevelled hair
that hair of yours from a storm cloud
stuck on the top of your head
And I thought
She is dead
And I wished
everything around us
would disappear
I wanted the world to be flat

and polished
like your hand
like the mirror which reflects
your hand
where once
to be two
to be a pair
your eyes shone
and your ears
and your legs
And I thought to myself
She will live her life through mine
And I gave the world to you
little by little
And I thought to myself
She will love me
with the insects
with the owls
and the moon
One evening
this evening illuminated by you
I wanted you
I want you
without me willing it
without a goal
without dream
You must not laugh
You must not yet learn
to laugh
for the first time
You are dead
You will stand up at my call
when dawn has extinguished
the lamp
You will walk on your shadow
without knowing
where your steps lead you
You will walk
towards me

who has been waiting for you forever
towards everything I invented
for you
towards the water and towards the fire
I carry for you
One evening
this evening haunted by you
I wanted you
I want you
as cold as on the first day
of the world
when water was marble
and fire was hidden
and trees were white
and the world had yet to be named
where the bird slept
And I think to myself
you are about to begin
that night
is going to fall
and it will make itself small
at your feet
for you to tread on it
And I think to myself
you are the world
and that you will reveal yourself
in one instant
and that you will understand everything
all at once
you will hear and you will see
and touch
with the nets
already moistened
as the sea draws near
And I think to myself
you will take off your dress
to burn naked
in the midst of yourself
The bee hums

at the tip of your breasts
the grass is pink
for your neck
the blood clots
at the corner of your mouth
the blood of all the living
and all the dead
impatiently waiting to rot
There are many
The earth is theirs
right into its bowels
The earth is theirs
down to the last lake
down to the last black rock
Night beckons to them
night sows stars for them
on its journey
for them to find again
under the beard of night's hills
in the shadows of birds of prey
And I think to myself
you are beautiful
there for me
in the middle of the night
and you will be beautiful
like the miraculous pulse of time
beating
at the heart of the sun
like the rain
coming down in the desert
on the hand reaching into the trees
for fruit
and the sob of the sand
just for water
just for the consolation and the smile
of water
messages to drink
from united palms
And I think to myself

you will be the first
to say my name
when the world wakes up
You will mistake
my arm or my leg for a road
You will think my head
is a crossroads
and you will walk on me
drunk on the world
And already
to welcome your footsteps
I am one with the ground
one with the snow one with the ocean
I swallow all the stones on the roads
which might hurt you
One evening
this evening
I wanted you
I want you
you who remain
you whose name
is apart from the earth
Outside time
my woman for all time
so close to day
and so close to night
diving everyday
engulfed
indifferent to the blood
which reddens fish
and the clouds
impervious to the bloody hands
of both hero and villain
One evening
this evening
I wanted you
I want you
alone in the world
waiting for

my love's first call
bent over
like a sleeping child
invisible
betrayed by his breathing
and you look towards me
and you wait for your life
knowing
your time has come
and you are about to rise up
forever
and you will be obeyed
because you hand out love
in the form of seeds
and light
and you know
that man is tired
in his empty abode
that he no longer has a heart
to nail on the wall
no tongue
no tears
no fists
nothing but his emptiness
which is like a gaping hole in his chest
like a well which creaks
when it fetches briny water
and that man will die
faceless
among his own ruins
and his noisy hatred
which burns through the night
One evening
this evening
I wanted you
I want you
I wanted hope
a green leaf on transparent water
a blue plait of visionary morning

and you are ready to run ahead of yourself
like a madwoman
ready to run on me and the world
with the wind
and the flying dust of the wind
screaming your name
my name
all along your exposed lips
your golden lips of love
before dawn
for a man
for the thirst and love of a lover
licker of dew
dealer in stars
in the screaming atoms of the earth
humiliated
ripped open
like a woman in labour

Translated by Dom Gabrielli from *Le Seuil, Le Sable*,
Collected Poems of Edmond Jabés, published by
Éditions du Seuil, Paris

Michael Florescu, 2009

LETTING ME GO
Michael Florescu

My first brush with death in New York City occurred in the Spring, the rarest and most limited of all the seasons in New York. A May morning. The confrontation in question took place in the Betty Parsons Gallery on West 57th Street. I had arrived at the gallery not more than ten minutes earlier, at ten o'clock. In my role as gallery director it was expected of me. The gallery opened to the public at 11, as I remember. It was the first Saturday of a new Richard Tuttle show. We were anticipating a big crowd. His opening the previous Wednesday evening had been very well attended, though very few pieces had sold. This was nobody's fault. Richard's work was not well known in 1977. Correction: it was well-known to a select few, but most people who were exposed to it then, in the early years of his career, were bemused by it. I was somewhat ambivalent about it, though I did try to conceal my ambivalence.

At 10.15 I was sitting behind my desk. I had arrived in good time not only because it was expected of me, but because I had left late the previous evening and my desk was horribly cluttered, and this was *not* expected of me. So my first job that morning was to tidy my desk. There was a ball of damp green moss in a saucer of hand-thrown pottery Betty had brought in from her house in Southold on the North Fork. I couldn't very well throw it out without seeming churlish. I could have taken it home with me, I suppose, but I liked having it on my desk. Next to this was a fist-sized model of Westminster Abbey embedded in a glass ball that released snowflakes when you shook it. This I had brought from London, a memento of my place of birth and of the school I'd attended. I'd found room for it in the single suitcase I'd brought with me when I uprooted myself from England and fulfilled my adolescent dream of living in America – which to me meant New York! – even though it meant relinquishing my competing adolescent dream of being a man of the theatre. The Westminster Abbey in the glass ball was also, coincidentally, a conversation piece. It was a good thing to have on my desk.

Two hardback books in their dustcovers and a jig-saw puzzle in its box were also on my desk. The books were Ernest Hemingway's *A Moveable Feast* which Lindsay, our secretary, derided for its self-important posturing, and Andre Malraux's *Anti-Memoires* which Betty, in her East Coast Puritanical-Buddhist mode, disapproved of for its opportunism and untrustworthiness. I pushed them to one side, but they would stay. I admired both Hemingway and Malraux. The jig-saw was a reproduction of one of my favorite paintings, Douanier Rousseau's *Surprise!* denigrated by many critics who were unaware that it was actually a disguised portrait of Paul Gauguin immediately prior to leaving his bank job for good.

The big heavy old-fashioned stapler didn't have to be on my desk. I put it away in a side drawer. Ditto the tape dispenser. Ditto the slide projector. A spinning top museum reproduction of the Bauhaus Color Wheel occasioned some indecision – sometimes I spun it mindlessly, the way Muslims twiddle worry beads. It was also a conversation piece. It could stay for the time-being, though there was little doubt that it contributed to the clutter. Then there was a heavy aluminum straight-edge, a long one, probably three-foot, and a mat cutter – a *box cutter* it's more generally known as nowadays. I put the box cutter away into one of the drawers. The straight-edge was too long for the drawers. It had to remain on the desk.

I cannot claim prescience or any heightened instinct for self-preservation, but there was a moment prior to my confrontation with he whom I will henceforth refer to as "the intruder" when I surveyed the desk and noted the remaining objects on it and was put in mind of the Roman cinerary urns in which the bones and ashes were placed along with a selection of objects belonging to the deceased, either as a farewell to the life recently ended or, alternatively, to accompany the soul of the deceased in the life on the Other Side. I seem to remember that the bones of the biblical King David were said to have been interred with a collection of circumcision knives, among other memento mori.

The old wooden lay figure, a beauty, was another memento I had brought with me from London. I wanted that on my desk. Between the lay figure and the Bauhaus Color Wheel, there was

no question which would stay. I put the Color Wheel away in the drawer. A bouquet of sharpened lead pencils and crayons filled a Harrods earthenware Stilton pot that my son had brought me when he stopped briefly in New York on his way to the Gulf Coast. The pencils would stay. They had to stay. And the pencil sharpener. It was a heavy-duty electric pencil-sharpener, a Pointomatic, the first electric pencil-sharpener I'd ever seen. I had been living on the planet close to forty years and I had never seen an electric pencil-sharpener. I had never even heard of such a thing. It seemed to me to be perfectly outlandish. That artists made use of them, indeed that anyone at all did, was as unimaginable as it was unnecessary. Perhaps they existed in Europe, I've no idea whether, thirty years ago, they did or not. Whether they do *now* or not. To me a lead pencil is a very special thing. Very special. It had been an extension of my fingers from a very early age. My favorite was a Venus 3B. I had been adept with it long before I learned to masturbate. So adept, in truth, that my ability to render a human likeness (with all the warts and hirsute outcroppings) had landed me in some bad trouble, and my parents into incidents of serious embarrassment. I'm trying to say that a pencil was and is for me almost sacred. I never pick discarded pencil up off the street of whatever length without thinking of poor schmucks in *solitary* deprived of any and every means of communication and the value put on even a stub by even the illiterate ones. So a pencil, I still believe, should be sharpened carefully, with all of one's attention with a pocket knife kept as sharp as possible for this single purpose. Even a mat knife would do, or any of those little knives that make use of razor blades. Pocket pencil sharpeners are okay, but their blades rarely stay sharp very long and the lead tends to break off. Best is a sharp knife. The facets on the wood made by the strokes of the knife are so much more interesting than the featureless little cone made by a sharpener. I stowed the Pointomatic (or was it a Sharpomatic?) away in the bottom drawer.

There was also a framed French postcard printed from a sepia photograph snapped by a street photographer in the Luxembourg Gardens at the turn of the century that showed my Great Aunt Queenie as a child riding beside Paul Gauguin in a

pony cart drawn not by a pony but by an ostrich. It was of course a collector's item, but to me it was infinitely more valuable than that: Aunt Queenie was the only member of my family, a renegade like me, who ever took me seriously. It was she who had introduced me to the world of art and who gave me a rather valuable nest egg before she died. I took the photograph off my desk and put it away. It was the last of the mementoes I had brought with me from London.

The remaining item caused me some indecision but, in fact, saved my life, which is to say it postponed my death: it was a miniature camera, a Minolta the size of a cigarette-lighter. I had discovered it in the pocket of a Melton pea-coat that was a size too small for me and had been left at a party in place of the pea-coat that was mine. Mine fit perfectly but there had been no miniature camera in the pocket. I was weighing it in my hand when I heard the faintest of sounds. I looked up and opened my hand and then closed it tightly over the camera. Standing there was the intruder. He had a leather satchel on a strap around his neck. The bottom of his satchel came to the top of the desk. I watched him slide his left hand into the open satchel and when he lifted his hand out there was a gun in it. I must have laughed, the kind of nervousness people have been known to expel at a funeral. "This ain't no laughin' matter," he said, "this is serious." And he pointed the gun straight at me.

In an instant, I was helpless, mesmerized. The intruder had me completely in his power. Strangely enough, I experienced no fear, only fascination. I was unable to keep my eyes off him. There was an alien quality about him, an otherness – recognizable but as if he were of another species. I've had this experience only once since, when I came eye to eye with a young red-tailed hawk that had become trapped inside our big barn. Detective Al Licata told me later that this was a perfectly normal response for someone in my position. The intruder's long, lugubrious face was neither black nor white nor brown. It had some of each in it. It was mottled like the skin of a toad, more like membrane than skin. A batrachian that had reached the limits of its capacity for metamorphoses. Was he out of his depth? Did he know it? And if he did, what then? It wasn't his

looks that were going to decide this thing, it was his trigger finger. Outdoors, near to water, among leaves and sedge grass and mosses, he would have been perfectly camouflaged. I wondered if he knew that. In those few moments before I submitted to him and he wound his rope around me, I knew if ever I were to see him again I'd recognize him, and this was not something I wanted him to know.

"Stand up!" The intruder's voice was somewhat hoarse, but not overly loud. I was thankful for that, unaccountably. "Get down on the floor. Face down."

"Okay…" I waited for a couple of beats, the time it would have taken to say, "Whatever you say." But I didn't, I did what he'd told me to do. As I gazed at the freshly painted grey concrete floor, maybe three inches from my eyes, I thought, for the very first time: "Make no mistake, boyo, you're facing death. This dumb junkie could blow you away in a second."

Then he was down on the floor beside me, or above me, I didn't know which, but in the next second, I felt his satchel swing against the back of my neck. I closed my hand tightly over the Minolta, and then he said:

"Hands behind your back. Wrists together."

What went through my mind then was that these monosyllabic phrases had been learned. The intruder had often – or always – been spoken to in monosyllables. Exclusively, most likely. I felt him lean on my back, maybe with the heel of his hand, maybe his knee, I had no way of knowing. It was of no importance. What was important, I was absolutely sure, was that I had to remember that he had never been spoken to except in monosyllables. To remain calm was crucial. I knew this too, and I began to take deep breaths. I shouldn't have, it made him mad. The sound of my deep breaths aroused his ire:

"Shut up! Shut the fuck up! Don't open your fucking mouth until I tell you to or I'll stuff your fucking throat with that thing around your neck. Now keep still. And keep quiet!"

I thought I heard him set something down on the floor, something metallic. His gun? Then I felt his hand edge its way into my back pocket, where my wallet was. There was a hundred dollars in new bills there, and ten or twelve in crumpled ones. I heard him pull out the currency and twitch it and drop

the wallet on the floor. I felt a sudden jerk on my neck. He was tugging on the silk foulard I was wearing, pulling it off.

"Wrists together," he said again.

The intruder rolled my foulard around my wrists and wrenched it tight, and I tightened my grip around the Minolta until he shouted. It was the first time he'd really raised his voice. "What you got there?!"

I opened my fist and dropped the Minolta. "It's a camera," I told him, "you want it?"

He commenced breathing heavily himself then, but he said nothing. He continued twisting the silk around my wrists, and then he was wrapping a rope around my ankles and tightening it too. My face was inches from the floor. Grey-painted concrete filled my field of vision. Surely this was not to be my last view of the world. We all have to go, I remember thinking – not an original thought – and we probably don't have much choice when or where or even how. How can I be so self-critical in this extreme situation, I thought too.

Suddenly I was inspired. "Ever see *Roman Holiday* – the movie?" I asked him in what I hoped was a perfectly normal voice. No reply. Oh well, a lack of acknowledgement was not unknown to me. "It's about a Princess who's travelling to Rome, Italy with a bunch of very stuffy officials, diplomats and so forth, and she runs off one night and gets herself picked up by this journalist, played by Gregory Peck, and he and his buddy, a photographer, give her a tour of the city by Vespa..."

"Vespa?"

Oh my god, he didn't know what a Vespa was! He was listening to me! I decided then and there to transfer my faith to Romulus, founder of the city of Rome, the wild jungle boy who'd been suckled by a wolf and who had willed my captor to listen to my tale. "A little Italian motor-bike. Anyway, the photographer, played by Eddie Albert, has a camera exactly like this one..."

"You a photographer?"

"Nope, but it's a great little gadget. Take pictures and people think you're lighting your cigarette. Personally, I don't smoke, and I'm not a photographer, so I don't need it, but if you want it help yourself – it's yours." I was inspired and scar-

ed and running on crazy as I ran off at the mouth. Whatever it took, I couldn't quit now.

"You got anything else? Any other stuff?"

"A gold watch," I said, "fourteen carats. Take it, it's yours. I don't need it. It's getting late. It must be – what? – almost ten-thirty. You better take whatever you came for and get going. Eleven o'clock and people start coming in. If you're still here, there could be trouble – for all of us, you and me and who knows what else?"

"Cash." Just the one word. He repeated it. His hand was inches from my left eye. It was whiter than his face, but his signature mottle was quite visible nonetheless. He released the clasp of my wristwatch and removed it. It was extraordinary how tenderly he did it. It was a Longines – pre-digital, naturally, rather a clunky design from the 'fifties, a present from my father on my 21st birthday. It had been his. He had bought a new one for himself – elegant, sleeker, much more to my taste. But he gave his old one to me.

"Cash."

"You've got all I have. If you'd come yesterday you could have had more. But Fridays we take the cash to the bank. It's the custom. Everybody does it. But take a look around. My boss's office is through that doorway. But be quick. Like I said, people start coming in soon, and you'll want to be on your way."

I remember wanting to take a deep breath, but I swallowed the impulse. His response was scary. I wasn't past this thing yet.

"Shit!" And with that just about everything that I'd left on the desk flew to the floor. The lay figure landed on my head, the glass ball with Westminster Abbey inside it shattered on the concrete floor somewhere beyond my field of vision. He must have swept his arm across the desk, scattering everything. And then I sensed him going away. For a minute or two, maybe three, I heard not a sound. I concentrated my attention entirely on listening. Afterwards, I explained this by reporting that I was listening for the sound of the safety catch on his gun being released. Perhaps I was, but I think I was just trying to figure

out what he was doing in Betty's office or if he had split. In a minute or so he returned, and spoke his final words:

"Don't move."

They were the last words anyone said to me for a while. How long was that? I don't know. Fifteen minutes, twenty? How long was I inside my foot-locker after my classmates bundled me in and sat on top of it and snapped down the clasps? In powerless situations the passage of time is difficult to calculate, or even guess. And I no longer had my father's watch on my wrist, and even if I had, my wrists were tied behind my back. Pretty much everything I had was behind my back, so to speak. There came a moment, though, when I did move. Very slowly. Also, I believe, imperceptibly. I moved my body imperceptibly until I was no longer looking at that freshly painted cement floor. I was still entombed in silence, and I think I heard the distant muffled sound of the elevator, but not stopping at the third floor. Not yet. It would be a while longer before it did. And when it did, and Betty and her nephew Billy came in, I was sitting up with my knees bent and struggling to spread my hands and fingers from the shackles of my own scarf. Betty's first word, after she set down her parcels, was *No*, and Billy was on the phone to the cops.

Then some other people came in, close friends of Betty's, I don't remember who but they were well and appropriately dressed for Saturday morning gallery-hopping – in the air were some enticing perfumes. A short while later, Richard Tuttle, the artist, arrived and he was down on his knees beside me untying the knotted ropes that bound me and my silk foulard that I had been able to loosen but not remove. Somebody, not Richard, not Billy, said, "I don't believe this." Betty, who did not seem to have moved from beside my desk, said *No* again. And then I was clasping and unclasping my hands, and as soon as the circulation returned, I was on my knees gathering up my bones and my ashes and the memento mori that the intruder had swept from my desk to the floor.

A little later, in response to the call Billy had made, the cops came by. When I say "the cops" I speak loosely. I ought to have said cop in the singular – in the person of Detective Alfred

Licata of the Manhattan Robbery Squad of the 20th Precinct
(with offices at 120 West 82nd Street, New York 10024). My
brush with death that morning was described more prosaically
by Detective Licata as Case #1359. Is my memory really that
good, that precise? No, it's good, but not that good – I've been
carrying around Al's card in my wallet, my succession of wal-
lets, ever since that morning in Spring 1977. Exactly thirty-two
years. Why? Who knows. A good luck charm? Maybe.

I told Detective Licata everything that had occurred but was
careful not to describe the intruder the way I have here. When
he asked if I'd be willing to attend a lineup of suspects, I said:

"Yes of course, but I didn't get a very close look at him – he
had a scarf covering the lower part of his face. He wasn't black
and he wasn't white. I don't know about Latino. I'd say he was
of mixed blood."

In answer to his question about the gun, I said I wasn't fam-
iliar with guns:

"I've never had one pointed at me before. I couldn't identify
it, no. I don't even know if it was loaded..."

I remember that I started to heave a bit, then, trying to take
deep breaths. Detective Licata asked me if there was anything
wrong. He was very simpatico.

I told him I was beginning to feel like a complete idiot,
which I was. "What if the gun wasn't loaded and I let him make
a monkey of me..." He didn't let me finish.

"We always assume the gun is loaded," he said, "and so
must you." He fixed the gallery-hoppers with his stare. And
then he turned back to me. "You did exactly the right thing."

"And how come I let him tie me up? He couldn't have done
it with one hand."

"Sir, don't even think about it. You did the right thing. I'm
going to take a look around now..." he had his notebook and a
ballpoint in his hands. "...and while I do, I want you to think
about this: Did you notice him on the street. Following you?
Chances are that's how he found his way here. He'd been fol-
lowing you."

"From the subway?" I said.

"Very likely," he said. "Try to remember."

I did try, but without success. I could only focus on how preoccupied with my own powerlessness I'd been, that I'd been unaware of what the intruder might have been doing after he ordered me not to move. I hadn't heard a thing. Yet the intruder (I never did learn his name) could not have done what he did in Betty's office, at my invitation, without making some kind of a sound. Then I was on my own.

Betty and her nephew, and Richard Tuttle, and the gallery-hoppers fell in behind the detective. A goodly number of them, I can't say how many, stared at me for a moment or two, balefully, accusingly, or with curiosity, before getting in step with the others. Their feet made an interesting sound on the concrete floors, heels and leather soles were very much in the majority, one or two were wearing rubber soles or tennis shoes. It sounded like a slow march of new recruits: all moving in the same direction, yet none of them in step. I remember staring at the rope that I'd been tied down with. It lay on the floor where Tuttle had left it. The double loop, very like an unfinished sheep bend or a bowline, could have been one of Tuttle's minimalist sculptures. Well, why not? Isn't that what minimalist art is: the artist's/poet's most profound yearning for meaning in the ignored or discarded bits and pieces of the mundane? I think that's what it is, and I thought so then as I picked up the piece of rope and wound it around my elbow and the space between my thumb and index-finger. Then I quit thinking about it and wondered where Lindsay, our secretary, was – why she hadn't shown up.

Lindsay showed up a little later, around a quarter to twelve, with some kind of an excuse but in plenty of time to help clear up the mess that had been made of Betty's office. The Congo totem, a marvelous free standing one about seven feet high, had been toppled. Thankfully, it had not sustained any damage. It was surprisingly light in weight, fashioned from a tree root, I recall. The intruder had swept everything off Betty's desk, just as he had with mine. But Betty's desk had been a good deal more cluttered. Amongst the clutter, which now had to be sorted through page by page, were notes and documents for her biography which she had decided to entrust to me. There were drafts of two chapters that had already been written by the Eng-

lish art critic Lawrence Alloway and found wanting. The biography was never written, not by Alloway, nor by me. In fact, it never made it past the mess of notes and documents on the floor of Betty's office. Also among the chaos left by the intruder was her read and re-read copy of *The Tibetan Book of the Dead* and one of Edgar "The Sleeping Prophet" Cayce's books of prophecy and reincarnation, a ball of living moss identical to the piece she had given me, a chunk of brain coral the size of a teakettle she had brought from her house on St. Maartens, a slightly smaller chunk of rock crystal, several packets of saltines layered with peanut butter, and a framed photograph of Betty with Bapak, the founder of Subud, an Indonesian religious cult of which she was an adherent. The photograph had been snapped earlier that year when Bapak had visited New York. There was a small framed crayon drawing of green figs. The drawing was mine. I had done it for her in London after she told me figs were her favorite fruit. It was quite a good drawing, I remember being pleased with it. It was unashamedly anthropomorphic, improperly so. Of course its glass was now broken. The only other things I can remember being on the floor were a cheap tin incense burner she had gotten in Chinatown and a paper packet of incense someone had brought her from Nepal, I believe. Betty told Detective Licata and the rest of us that morning that the only thing of value that she was missing was an envelope containing cash, nine hundred and something dollars, she said. To me she said nothing. Not that morning, not the following Tuesday when the gallery re-opened after the weekend, not later that week, not ever. She never said a word to me about the incident.

On the last Tuesday of the season, before the gallery was to close for the summer, Betty said she'd like to take me out to dinner. Thursday or Friday would be best for her, she said. We settled on Friday. She suggested her favorite place in the Village: The Gran Ticino. I had never been there but it was okay with me. It was little more than a five minute walk from my apartment on Prince Street. I got there shortly before she did. She had called ahead and booked a table. I sat down and ordered a glass of their house white. I had changed my shirt and

wore my old school tie and the good herringbone jacket I had brought with me from London. I had worn it the night I was introduced to Betty in London. Betty had also changed clothes. She wore a black beret over her bobbed grey hair and a long scarf that went around her neck three times with the two ends hanging down. If it had been re-wound carefully it would have gone around her neck once more. She was impatient with the maitre d' who pulled out her chair for her. Once seated, she unwound her scarf and folded it in two and settled it around her shouklers and under her arms like the wings of a bat

"The usual, madam?" said the maitre d.'

Without looking at him she said, "Yes, a Manhattan." Then looking at me she said, "In all the years I've been coming here, they've never learned how to adjust the air conditioner."

She got down to business immediately, though I didn't recognize it immediately.

"Who are your favorite gallery artists?" was her opening question.

I was on the point of saying: Pollock, of course, and Rothko, and Barnett Newman, Ad Reinhardt, et al. This had been my answer when she asked me the same question the night we met in London. It was the one piece of tactlessness I'd been guilty of, because they were all dead and either they or their widows, or in the case of Mark Rothko his daughter, had betrayed her by going with rival galleries, notably Sidney Janis. So I caught myself in time and said:

"Bradley Walker Tomlin – I love his work." Which was true, I did.

"He's terribly underrated, I think." Betty agreed.

So far, so good, I thought. "Pousette-Dart. Mysterious. He reminds me in a weird way of Odilon Redon." Betty said nothing, then she picked up the menu. I wondered where we were going. "Walter Murch." Murch could be kitsch, but he handled paint beautifully, however he was scarcely known. "Saul Steinberg." I was safe to mention him despite his having hedged his bets by splitting his allegiance between Betty and Janis. "Hedda." Hedda Stern was Steinberg's ex-wife, and though an original and distinctive artist, ex-wives of world-famous artists never did very well in the art market.

Betty caught the eye of the maitre d' and pointed with her wrinkled little-girl forefinger at her empty glass.

I was trying to answer her question honestly but prudently, and I still didn't know where she was bound for, what her follow-up would be.

"Tuttle," I said confidently. After the untying of the rope, I no longer felt ambivalent about Tuttle or his work.

"Yes, yes, of course." Betty was becoming impatient.

"Paul Feely."

"No ambition."

"Cleve Gray," I said. Suddenly I had her attention again. She'd dropped the menu when I said Cleve Gray.

"He's one of the greats," she said. "But no one will know it until after his death, *and* after that. It'll be a long time. I'll be gone by then." My mentioning Cleve Gray had hit a nerve.

"Why do you say that, Betty?" It was a perfectly innocent question. I ought to have known better. A waiter brought her another Manhattan and she took a good long draught of it before delivering a stab:

"If you decide to remain in this business, Michael, you'll come to realize that for an artist to succeed in the world, he needs a wife who will sacrifice her ambitions, not a wife with ambitions of her own – unless he has a dealer he can trust, and who his wife – however ambitious – can also trust." She finished her second Manhattan, and moved her hand around as if she expected another drink to have materialized. "Cleve is one of the greats, but his personal life is not...is not..." She was looking for me for help.

"Not conducive?" Then I tried, "Conducive to his undivided attention." I waved to the waiter. If she needed alcohol to deliver me the *coup de grace*, I was perfectly willing to cooperate.

"Cleve is a wonderful artist. He has very great spirituality. But he will need to be more resolute in the face of..."

She looked at me again for help, but I didn't want to get into it any more than I had. I regretted bringing up Gray's name. And still I had no idea where all this was leading. Or rather, I knew it was leading to her pink-slipping me, but I didn't know what her rationale would be. Then we ordered, and I wished I'd

known ahead of time about The Gran Ticino's air conditioning being so punitive. My Scotch Tweed herringbone jacket wasn't enough. I tried to order a mulled wine and, having failed, a hot cider, but was told it was not the season, so I shivered, awaiting the executioner's axe.

"You have very good taste in art, Michael...a first-class eye. But I'm twice your age, and I'm interested in youth! I'm fired up by youth – fired up, exultant!" She was, it's true. "I'm exultant about youth, the new generation of artists..." She named a few names. "But you're not. You're stuck in the past. With the tried and the true. The dead and the dying. Open your eyes to *youth*, Michael. Open your eyes to the light!"

As it happened, I finally did see the light in regard to her rationale for firing me. Our food arrived. At adjoining tables, people were listening to her, staring at us.

"The light of the Future will always be stronger than the light of the Past. When I returned to the United States from Paris, I was returning to the light and leaving darkness behind. It's why I returned. I was determined and I was thrilled – yes, *thrrrrilled* to become a part of the youth and the greatness of America! You're young, but your heart is still in Europe, sad to say..." A slice of scaloppini Milanese had been waiting patiently on her fork, which she had set down on her plate during her call to arms. "Now take my godson, Jack." She raised the fork to her mouth and began chewing before her teeth actually made contact with the meat. I waited patiently until she had chewed it one hundred times, as was her habit.

What could I possibly say? Nothing. Particularly as I knew what was coming.

"Jack is a generation younger than you are. Mention any of the names you mentioned to me – any one – and Jack will wrinkle his nose and duck his head and shrink into his anorak and hem and haw. He knows their work and he loves it, but he loves it as a boy, or a girl, loves his granddaddy or his grandma. But you mention..." and here she mentioned more names of young unknowns "...and watch his eyes light up as he straightens himself up and opens his arms. Oh, it's marvellous, simply mar-vellous to witness. That's why I'm taking Jack into the gallery. I've already discussed it with him, and though his fam-

ily would prefer him to be going into a less risky business than art dealing, I think he'll do very very well. Don't blame yourself, Michael. You have a great future, too. But it's a different future. I can tell you're disappointed at my saying what I'm saying, but you'll thank me for it one day. Now eat up. They have wonderful desserts here. Their rum babas are specially good. Scrumptious, in fact. Barney loved their babas. In some ways you remind me of him." She was referring to Barnett Newman.

Well, I was Jewish, whatever that meant to her, and I did have a tendency to pontificate. Otherwise...?

I have very little more to say regarding this episode, except two things. First, Polyanna that I am, I very quickly understood that for me to have remained Betty's gallery director any longer than I did would have been dumb. The other thing is that I was never able to understand Detective Licata's assumption that the chap that mugged me must surely have followed me from the subway. To this day I fail to understand why he picked me.

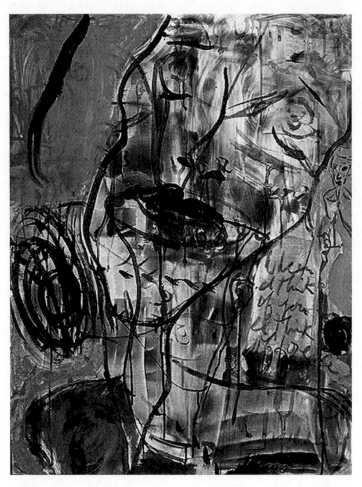

Marcus Reichert, *Woman's Head in Green*, 2002-2004

ON DYING
Marcus Reichert

When we can no longer remember
our life unfolding with any vitality,
no beauty known beyond our own
deterioration, adrift in a static sea
of compliant malignancy, yearning
for the shifting detritus of summer
to smother the forest's pristine floor,
we are flowers burst into useless flame
upon the bed in which we were born.

He said, walk here with me and I did.
The street was not his alone, it was shared
by others, by mere mortals like myself.
Whosoever walks here is mine, he said,
and I shall have them utterly and completely.
Now my thoughts are beating, alive without
respite, as I endure the torment that is his —
mute flowers burst into flame, left to endure
the silence of loved ones awkwardly waiting.

The woman who takes me down into the
smouldering leaves of my thought also opens
the sky wide with redemption as I plainly see
the sympathy of others alone in their fear,
knowing they shall, like me, finally lie down
somewhere within the misbegotten vastness
that is the grandeur of our oblivion. Mingle
with me, she says, as we are taken beyond
the cinders of sun and moon to where we began.

204

REPRODUCTION CREDITS

All reproductions of works of art courtesy of the artist, or as otherwise noted, with the exception of those images retrieved from news sources: permissions granted solely in the context of the academic work *Art & Death*.

Francis Bacon, *Dog*, 1952 © Estate of Francis Bacon, Courtesy of Faggionato Fine Art, London. Page from Antonin Artaud's Notebook (1947) © Bibliothèque Nationale de France, Bequest of Paule Thévenin, 1994. Hans Namuth, *Jackson Pollock*, 1950 © Hans Namuth Estate (Musée d'Art Moderne de la Ville de Paris). All unidentified full-page images © Marcus Reichert.

Portraits have been provided by the photographers or otherwise retrieved from news sources wherein the photographer was not identified: all portraits under copyright to the individual photographer. The following photographers have very kindly allowed the use of their images all of which are under copyright to the photographer: Serafina Kent Bathrick, Victoria Cohen, Guy Lane & Simon Lane, and Mark Luscombe-Whyte.